EXECUTIVE EDITORS

D1296538

PHOTOGRAPHER
BPD Studios

CONTRIBUTING PHOTOGRAPHER
Katie Whitt

VIDEOGRAPHER
Jake Doan

DESIGNER & TECHNICAL WRITER
Linda Johnson

PROJECT DESIGN TEAM
Natalie Earnheart, Jenny Doan,
Sarah Galbraith

CONTRIBUTING COPY WRITERS
Katie Mifsud, Jenny Doan, Camille Maddox,
Natalie Earnheart, Christine Ricks, Alan
Doan, Sarah Galbraith

COPY EDITOR
Geoff Openshaw

CONTRIBUTING PIECERS
Jenny Doan, Natalie Earnheart,
Stephen Nixdorf, Cassie Nixdorf

CONTRIBUTING QUILTERS
Bernice Kelly, Deloris Burnett, Jamey Stone,
Kathleen Miller, Betty Bates, Adrian Stacey,
Emma Jensen, Sherry Melton, Cassie Martin,
Amber Weeks, Sandi Gaunce, Daniela Kirk,
Amy Gertz, Patty St. John, Mari Zullig

CONTACT US
Missouri Star Quilt Co
114 N Davis
Hamilton, Mo. 64644
888-571-1122
info@missouriquiltco.com

content

HELLO from MSQC

> " We hope our magazine— BLOCK will inspire you to create beautiful quilts. "

We have a beautiful redbud tree in our front yard. Every year in spring, it is in full bloom, covered in the most glorious color of pink you can imagine. It reminds me of the newness of the season because even though the redbud doesn't even have leaves yet, it is covered in these wonderful flowers. We have a tradition of always lining up in front of this tree for family pictures.

One great occasion for family pictures is Easter. When our kids were small, we searched for matching Easter outfits. The girls always had matching dresses, hats, and gloves. The boys got new ties and shiny shoes. It was a big deal for our young ones to dress up so fancy; even the tree seemed to get dressed up! What wonderful memories we have in front of that tree.

Here at Missouri Star Quilt Company, we have had a very busy run-up to the Easter season, and we are constantly reminded about how blessed we are. Recently, we were featured in the Wall Street Journal and had a spot on NBC Nightly News with Brian Williams. Us! Our little company in Hamilton, Missouri! How amazing is that?!

In that spirit of gratitude, we hope that you and your loved ones have a wonderful Easter season full of love, blessings, and warm memories! We wish each of you the very best!

Jenny

JENNY DOAN
MISSOURI STAR QUILT CO

HELLO
spring!

Spring is my favorite season. It brings with it new life. I enjoy the little green buds poking their heads out of the deep rich brown earth. Also, bringing with them the bright palettes of purple crocuses, red tulips and pale pink blossoms on the trees; blue skies with the yellow sun to warm everything up and red robins returning with their cheerful tunes. Everything bursts with fresh, bright newness.

All this inspires my own desire to create! I have pulled some of my favorite bright prints and solids from the stash here at MSQC. I hope you enjoy this spring bundle full of fun floral bouquets and bright bold shapes. It's a spring gathering of our favorite fabrics that reflect the colors of the season. We here at MSQC hope this opens your flood gates of inspiration and finds a way into your next budding project!

CHRISTINE RICKS
MSQC Creative Director, BLOCK MAGAZINE

SOLIDS

FBY11290 Citrus - Small Stripe Aqua
by Another Point of View for Windham Fabrics
SKU# 37515-8

FBY1288 Bella Solids - Yellow
by Moda Fabrics
SKU# 9900 24

FBY9583 Think Pink - Dots
by RBD Designs for Riley Blake
SKU# C3703-PINK

FBY1433 Bella Solids Pink
by Moda Fabrics
SKU# 9900 61

FBY1273 Bella Solids Ochre
by Moda Fabrics
SKU# 9900 79

FBY11489 Star Spangled - Stripes Blue
by Doodlebug Designs for Riley Blake
SKU# C3765-BLUE

FBY1266 Bella Solids - Jade
by Moda Fabrics
SKU# 9900 108

PRINTS

FBY11494 Color Me Happy - Teal
by V & Co. for Moda Fabrics
SKU# 10821 13

FBY11287 Citrus - Small Check Yellow
by Another Point of View for Windham Fabrics
SKU# 37514-7

FBY11328 Palm Springs - Beads Pink
by Michele D'Amore for Benartex
SKU# 036201B

FBY9252 Bungalow - Dainty Daisies Emerald
by Joel Dewberry for Free Spirit Fabrics
SKU# PWJD078.EMERA

FBY11543 Mormor - Blomster Coral
by Whistler Studios for Windham Fabrics
SKU# 37116-2

FBY11492 Color Me Happy - Lime
by V & Co. for Moda Fabrics
SKU# 10820 15

FBY11326 Palm Springs - Tulip Navy Blotch
by Michele D'Amore for Benartex
SKU# 0396155B

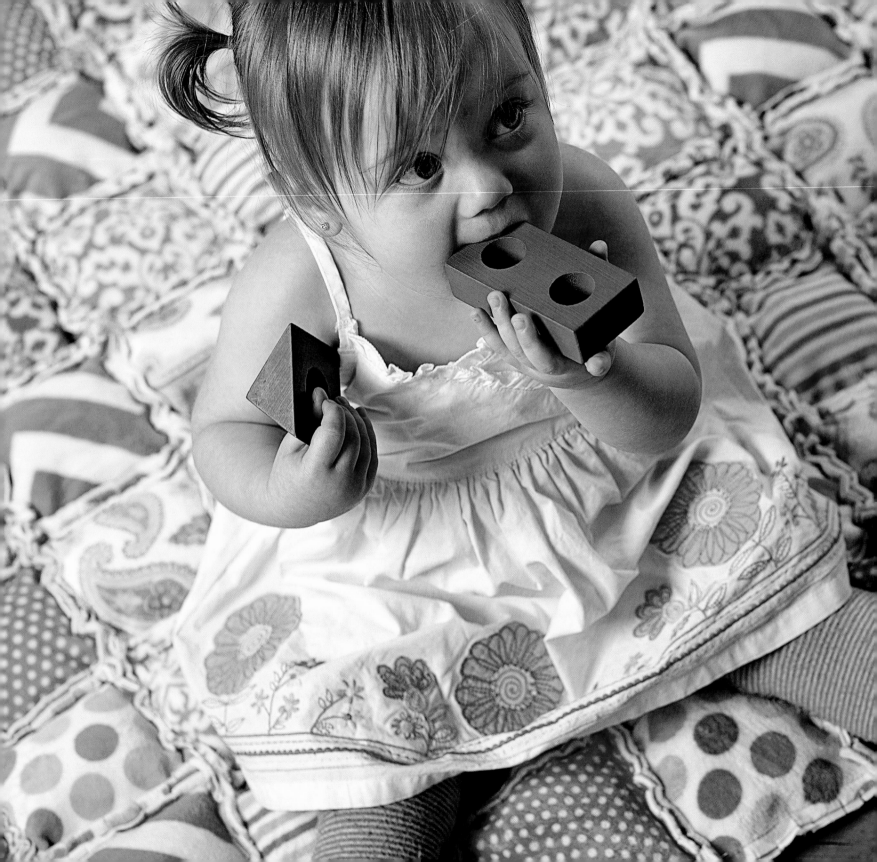

A head in the clouds

and a quilt on the bed

quilt designed by NATALIE EARNHEART

The smallest airplane I've ever flown in was a small, nine-passenger plane that took us between two Hawaiian islands. I couldn't stop thinking how I could have filled the entire plane with my family alone! It was a bit nerve-wracking to be so high above the ground in this teeny little tuna can with wings, but overall it turned out to be a pretty cool adventure. I had a great view of the islands: mountains, beaches, jungle and lava fields. But to be honest, the thing I remember most is the clouds.

Unlike large jumbo jets, small airplanes don't get much altitude, so the plane ends up nestled right among the clouds. So close up, those fat Hawaiian clouds looked fluffier, creamier, and snugglier than I

*THIS QUILT COMBINES rag
quilting and quilt as you go, two of
our favorite quilting techniques!*

have ever seen before or since. I wanted so badly to crawl out the window and burrow into one of those celestial dollops of whipped cream. Of course, I didn't let my cartoon-warped imagination get the better of me - I stayed fixed to my seat - but I've always wished there was a way I could take a blissful little nap on one of those downy clouds.

As time passed, the cloud-cushioned nap fantasy drifted from my memory, but when I made this Cloud Quilt, my mind zoomed right back to those buttery soft Hawaiian clouds! I have to admit I have a total love affair with cuddle fabric (cuddle cloth, minky, whatever you call it, I love it!). Stuff it with a little fluff, sew it into a simple quilt, and all my coziest dreams come true! So I couldn't wait to make these up for all

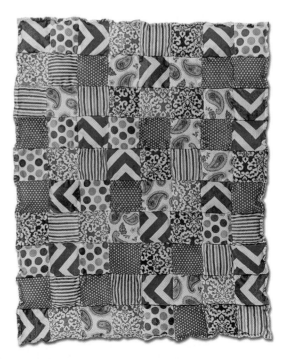

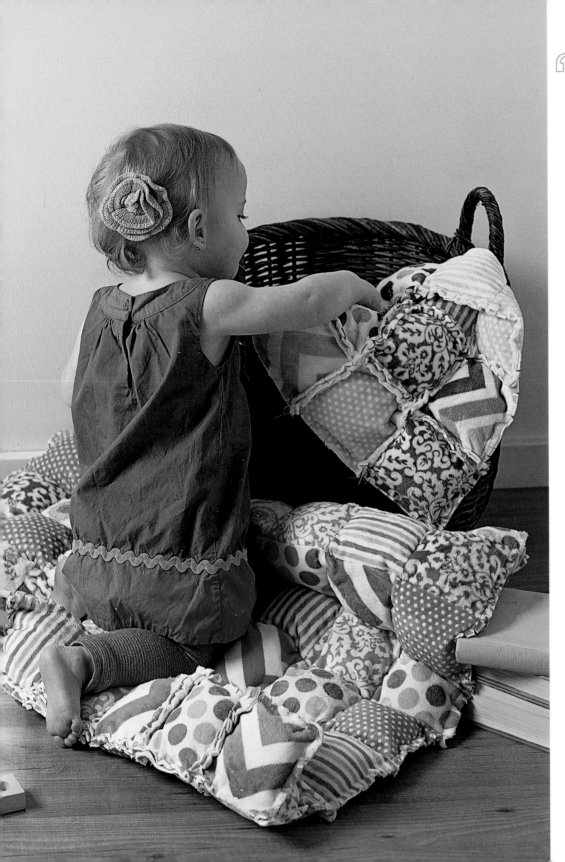

> " The only thing missing from this pattern is a chubby-cheeked bundle of joy "

my grandchildren. The only thing missing from this pattern is a chubby-cheeked bundle of joy crawling across it!

This wonderful Cloud Quilt goes by many names: biscuit quilt, puff quilt, or bubble quilt. However, the traditional biscuit quilt method can be a bit fiddly and usually requires darts or pleats to make the puff. With our Cloud Quilt, we've revisited the traditional biscuit quilt and made it faster, easier, and, of course, cuddlier: everything you need to take you straight to cloud nine!

11

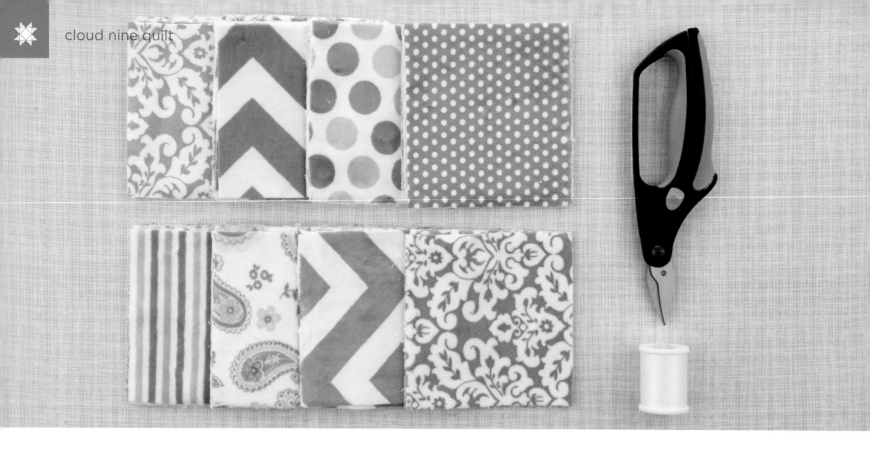

materials

QUILT SIZE
35" X 43"

QUILT TOP
8 charm packs

EXTRAS
Rag Quilt Snips by Fiskars
polyester stuffing

SAMPLE QUILT
Girly Girl Cuddle Cloth
by Shannon Fabrics

1 layout

Pair up charms of the same print WST and layout in an 8 x 10 grid. Back and front will be identical.

2 sew charms

Sew all charms in rows first. You will be layering 4 charms together; only the middle 2 charms will be RST. Backstitch at the beginning and end of these seams. Just as in a rag quilt, all seam allowances are visible on one side of the quilt.

Now you have a row of 8 charm pairs sewn together, all seams facing up. To complete the row sew the first and last charm pairs shut WST along the side edge. This will create the first and last pockets of each row.
Make: 10 rows

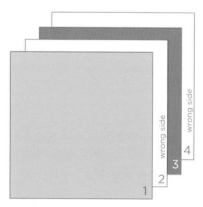

1 pair up charms WST

2 sew 2 pairs together. Charms 2 & 3 have right sides facing.

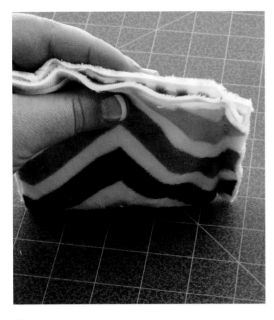

1 You will have 4 layers of minky when sewing blocks together. Remember to backstitch your seams.

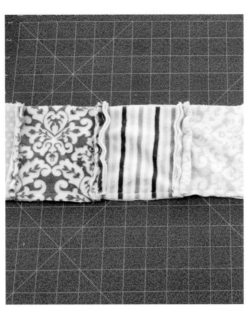

2 All seam allowances are visible on one side. Sew along the bottom and sides of a completed row to make the stuffing pockets.

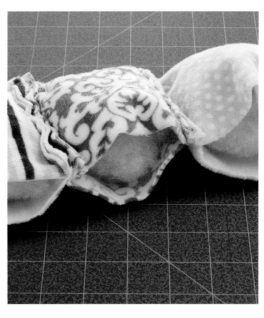

3 Stuff the pockets but do not overfill.

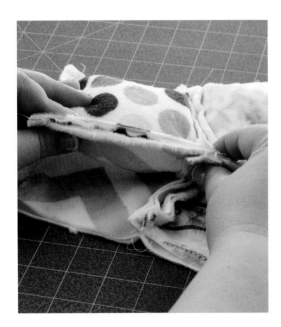

4 Sew the row filled with stuffing to the next row. To match seams push one seam forward, the other back. Or, you can open both up.

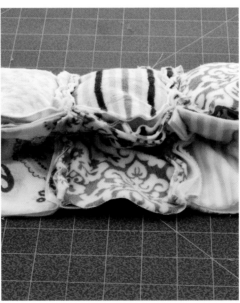

5 The next row of pockets are ready to be filled.

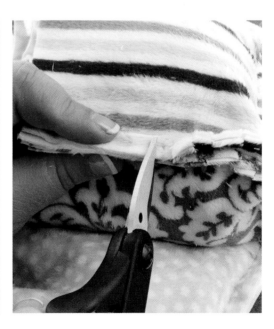

6 Use rag snips to make ¼ inch cuts in the seam allowances.

2 first & last charm pair in each row is sewn shut WST; all seam allowances face one side.
3 bottom row: sew across the bottom of all charm pairs; pockets now ready to stuff

4 clip the seam allowances

3 sew rows & stuff

Start with the bottom row. Sew across the bottom of all the charm pairs. This creates 8 pockets. Fill with a handful of polyester stuffing. Be careful not to overfill.

Sew the open side to the bottom of the next row above: 4 layers of minky. Nest the seams as you go, pushing one seam allowance forward, one back as they meet. The next row of pockets are ready to fill. Stuff these and sew these open pockets to the next row above. Repeat for all rows. For the top, simply sew the pockets closed after you have filled them.

4 clip

Using a pair of rag quilt snips, cut the seam allowances at ¼" intervals to create the raggy look. Rag snips are designed to cut through the thickness of multiple layers of fabric and save your hands from soreness with their padded handles. They are highly recommended.

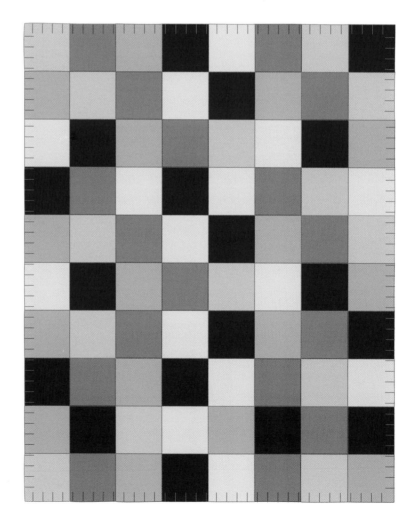

make
any day
seem
Flower
Fancy

table runner designed by Jenny Doan

When my children were small, dinner was a special time. We have a large and active family and dinner was the one time during the day that we were all together in one place. In order to teach our seven children to be helpful and self-sufficient, my husband and I decided to assign each of them a day of the week on which they would be responsible for dinner. On their assigned day, each child was in charge of planning the menu, helping to prepare the food, and cleaning up and doing the dishes.

Because we had so many mouths to feed on a very tight budget, we had to get creative in order to make dinner feel really special. For example, if we had macaroni and cheese, we'd break out the good china and eat by candlelight. After all, it's all in the presentation, isn't it?

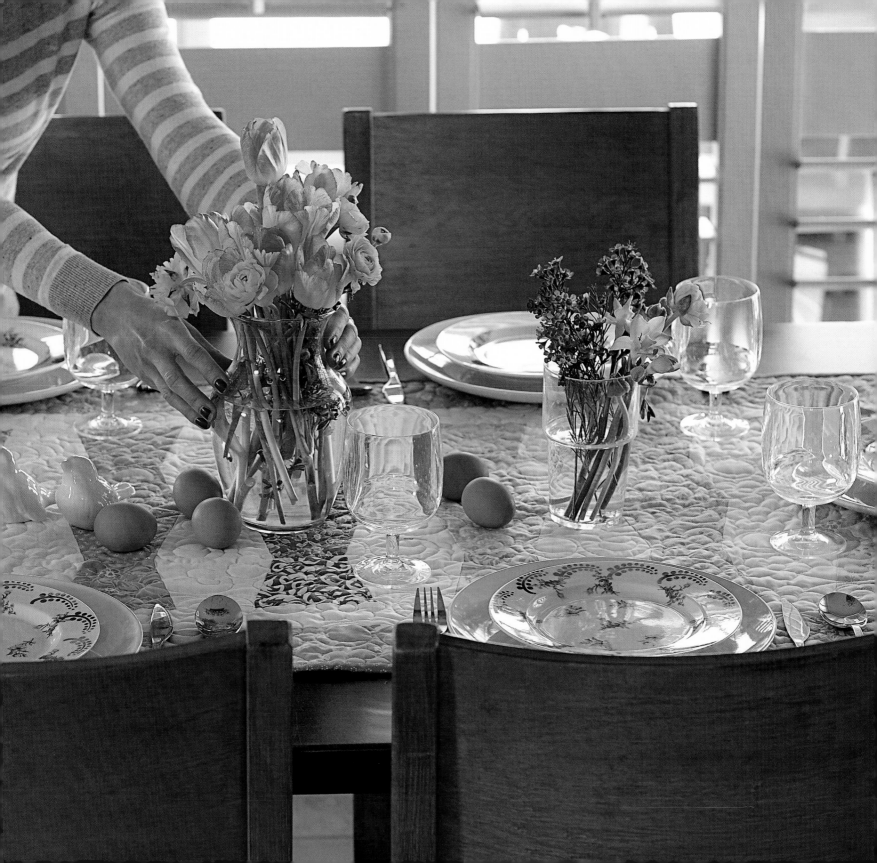

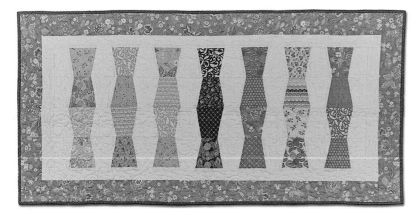

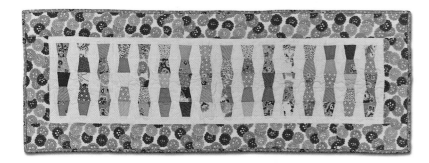

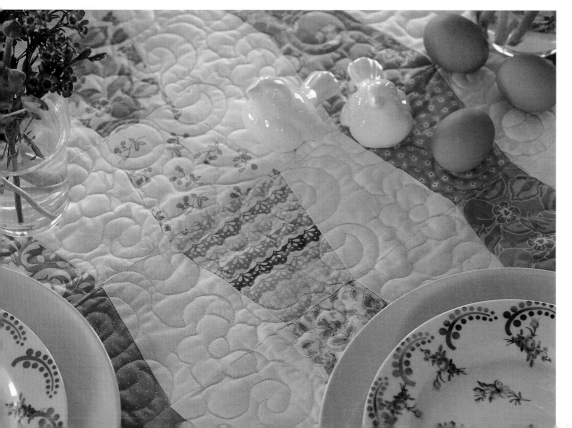

Every once in a while we would have an evening we called "The French Fry Bash." The kids thought it was just wonderful and didn't realize until they were all grown up that french fry night was born of necessity rather than fun: those were the nights that we just didn't have any food other than potatoes!

You know, even the most humble meal can be made to feel extraordinary with the right atmosphere. That is why I love table runners so much. All you have to do is put a different runner on the table and the whole look and feel of the room changes. Table runners can add a festive touch to any holiday, birthday, or season, but they can also make any ordinary day seem special. I couldn't provide steak and lobster or seven courses of fine dining to my kids, but when we gathered our young family around the beautifully dressed dinner table, it was easy to forget our humble circumstances.

A BEAUTIFUL TABLE RUNNER can add a special touch to your table on any day of the year!

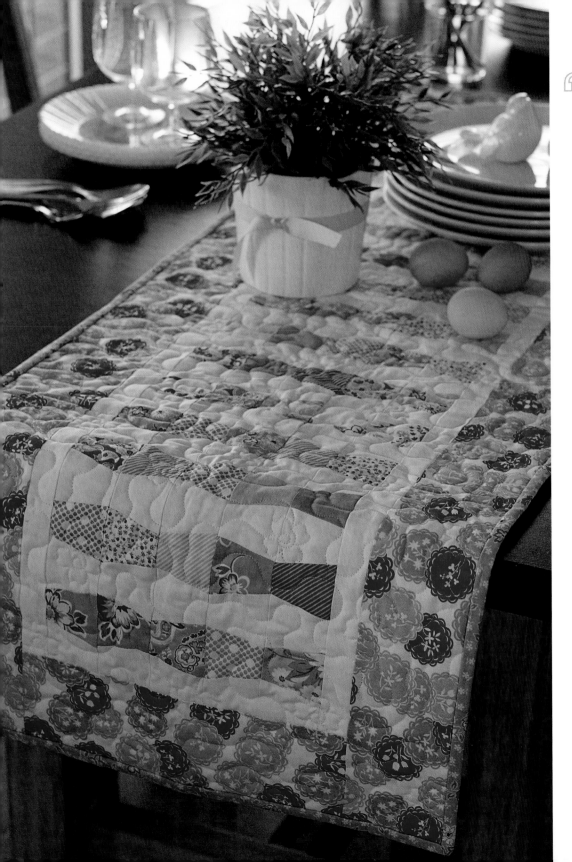

"Even the most humble meal can be made to feel extraordinary with the right atmosphere."

Even though times were hard, our kids never knew how poor we were because we took the time to create our own five-star experiences. I love the saying, "It is not how much you do, but how much love you put in the doing." And nothing says love like a pretty table. We may not have eaten like kings, but those little, special touches sure made us feel like royalty. More importantly, the time we spent gathered around the dinner table strengthened us as a family. And that is a bond so precious to me it is worth more than anything money can buy.

materials

TUMBLER CHARM TABLE RUNNER SIZE 30" X 60½"	**MINI TUMBLER CHARM RUNNER SIZE** 17½" X 57½"

TUMBLER CHARM TABLE RUNNER
- 1 charm pack
- 1 yd inner border & bkgnd solid
- ½ yd outer border
- ⅜ yd binding
- 1⅞ yds backing

MINI TUMBLER CHARM RUNNER
- 2 mini charm packs
- ¾ yd inner border & bkgnd solid
- ⅜ yd outer border
- ⅓ yd binding
- 1¾ yd backing

TOOLS
- MSQC Tumbler Charm Ruler

TOOLS
- MSQC Mini Tumbler Charm Ruler

SAMPLE TUMBLER CHARM TABLE RUNNER
- **Mirabelle** by Fig Tree & Co. for Moda Fabrics
- **Bella Solids Bleached White PFD** (97) by Moda Fabrics

SAMPLE MINI TUMBLER CHARM RUNNER
- **Scrumptious** by Bonnie & Camille for Moda Fabrics
- **Bella Solids Bleached White PFD** (97) by Moda Fabrics

1 select & cut

Choose 7 sets of 4 charm squares each from different color groups. For example, 4 peach, 4 cream, 4 brown, etc. 7 times.

Use the MSQC Tumbler Charm Ruler to cut tumblers from all 28 squares in the color groups.

1 cut tumbler shape from print charm squares

1 cut tumbler shape from 5" background strips

Cut (4) 5" strips of background fabric. Sub-cut into tumblers using the ruler. Make sure to flip the shape as you cut the strips—it's quicker and saves fabric too!
Make 32 background tumblers

2 arrange

Lay out the tumblers in a row of 15. Begin with a background solid and alternate between color groups. In the next row, set color groups in the same sequence but flip tumblers to match tops & bottoms of previous row. Make 4.

3 sew & straighten

Start at one end of a 15-tumbler row. RST sew along the side edge of adjoining tumblers. Make sure to create dogears at the ¼" seam allowance. Press to the dark side in rows 1 & 3; to the light side in rows 2 & 4. Make 4 rows.

Sew rows RST nesting seams as you go. Press.

To straighten both ends line up a straight edge ruler to the zig zag edge. Cut about half of the last background tumblers off. Remember there will be more background fabric added when the inner border is attached.
Table runner center: 18½" x 49"

2 alternate color & background tumblers; match tops & bottoms from row to row; colorways follow same sequence

3 sew tumblers together in rows

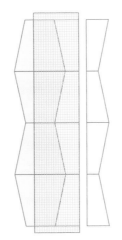

3 trim zig-zag edges

Alternate between print and solid tumblers matching sides. Offset the edges slightly to reveal dog ears.

4 borders

Cut (4) 2½" strips of background fabric for the inner border. The following steps will help keep your runner square and flat.

Start with the short edges. Measure the width of the runner in three places: top edge, bottom edge and through the middle, folding the runner in half width-wise to find the center. Cut 2 strips to the average measurement. Stitch a strip to each short side RST. **A** & **B** The border fabric should be on top as you sew. This method will reduce wavy borders. Always press to the borders.

Measure through the center lengthwise for the side borders. Include the newly attached borders in your measurements.

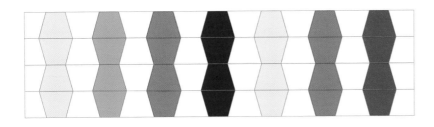

21

attached borders in your measurements. Cut 2 strips to that length, piecing strips together when needed. Attach one to each long side. **C & D** Press to the borders.

For the outer border cut (4) 4" strips. Attach in the same manner as the inner border.

5 mini tumbler runner

To make the Mini Tumbler Charm Table Runner, use 2½" mini charm squares and the MSQC Mini Tumbler Charm Ruler.

Cut 5 each of 16 print colorway groups (80 total); and 85 background tumblers from (4) 2½" strips. Lay out is a 5 x 33 grid. **Runner center:** 8" x 48"

Cut (3) 1½" strips for inner border; (3) 4" strips for outer border.

6 quilt & bind

Layer runner top on batting and backing and quilt the way you like. Square up all raw edges.

Cut (5) 2½" strips of binding—(4) 2½" strips for mini runner—and piece together end-to-end with diagonal seams, aka the plus sign method. Fold in half lengthwise, press. Attach to your runner raw edges together with a ¼" seam allowance.

Turn the folded binding edge to the back and tack in place with an invisible stitch or machine stitch if you like.
Runner size approx: 30" x 60½"
Mini Runner approx: 17½" x 57½"

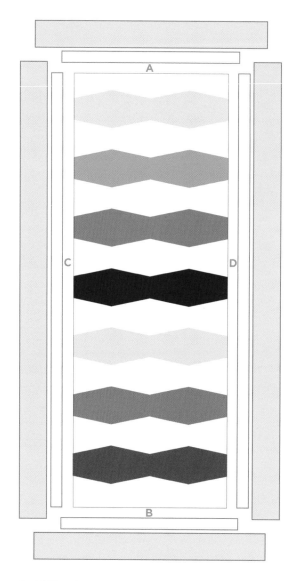

4 add borders

5 mini tumbler charm runner

Zip 'Er Up

quilt designed by JENNY DOAN

In 1937, Esquire magazine endorsed the "Newest Tailoring Idea for Men," a great new invention that promised to eliminate "The Possibility of Unintentional and Embarrassing Disarray." What was this miracle of function and fashion? Why, the zipper, of course! A 1930s ad for these "slide fasteners" declared that they "...give a gay, decorative accent to your new blouse, sweater, or down the entire front of your new dress. Use them anywhere."

Besides adding accents and preventing embarrassing disarray (and by the way, thank heaven for that. I'm so tired of dealing with disarray. So embarrassing!), the newfangled zipper soon became a quick fix for everything. Today, the average American winds up with fourteen new zippers a year, and some of us way more than that between boots, bags and jeans. Heck, I own a purse that has nearly fourteen zippers all by itself!

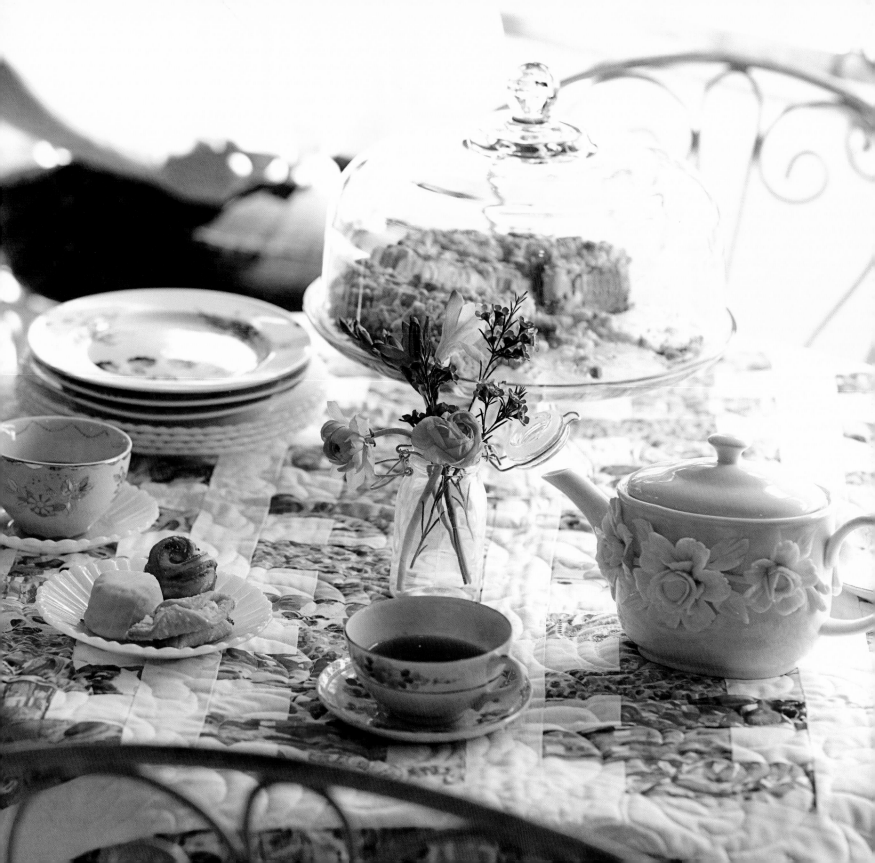

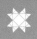
"Zippers hide no more...designers are drawing attention to them again, throwing them on everything from hair accessories to jewelry to the front of your dress."

Zippers must have fallen out of favor somewhere along the line. Fashion designer Yves St. Laurent once scrapped a multi-million dollar fragrance commercial and had it entirely re-shot because the model's zipper was visible. But today, zippers hide no more. Designers are drawing attention to them again, throwing them on everything from hair accessories to jewelry to the front of your dress. What had become just a functional part of fashion has risen to new stardom. Step off, Velcro, we love the zipper!

I think it's an adorable trend, and I said to myself, "Why let the fashion industry have all the fun? Quilters love fun!" So I set out to design a zipper-inspired quilt. This

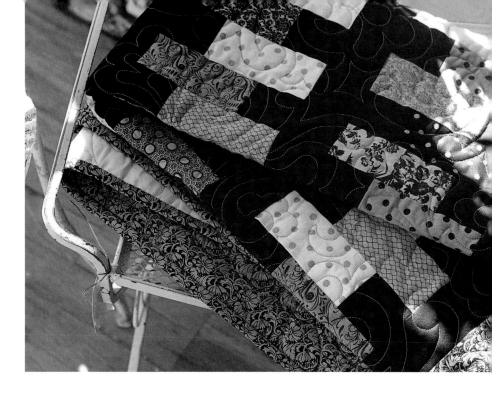

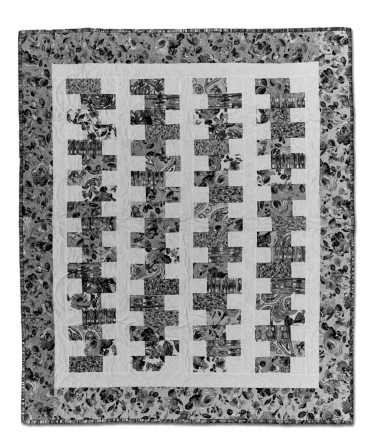

pattern could work with any fabric you like, but you might want to go with spring tones so that you can use your quilt when you celebrate Zipper Day on April 29th (Yes, zippers have their own holiday.) But when it comes to Zipper Day, some of the celebration ideas I've heard sound somewhat . . . um . . . less than festive, like, "Get your broken zippers fixed." For some reason, the idea of taking my broken zippers to the tailor doesn't really set my heart aflutter, so I'm thinking that making or enjoying a zipper quilt is gonna be your best bet to make the most of this unusual holiday!

So give this zipper quilt a whirl. It's easy, it's cute, and if your state of "embarrassing disarray" is just beyond help, you can curl up on the couch, wrap up in your gorgeous zipper quilt, and forget the whole thing!

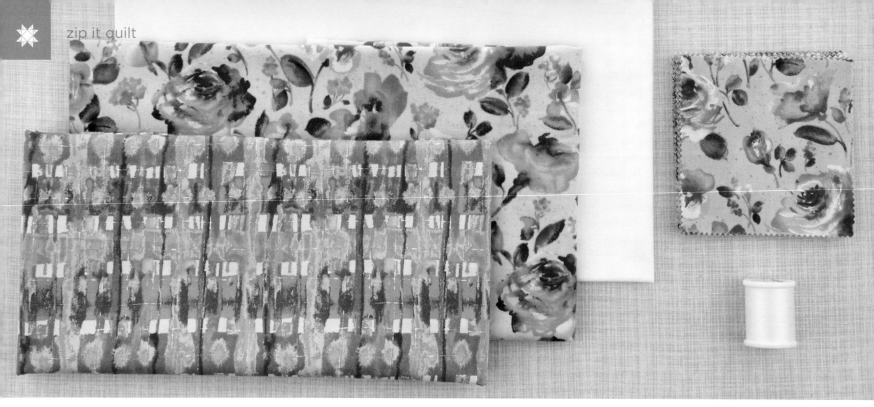

materials
makes a 45" X 51" charm pack quilt

QUILT TOP
- 1 charm pack
- 1 yd solid for sashing, cornerstones, & inner border
- ¾ yd outer border

BINDING
- ½ yd coordinating fabric

BACKING
- 3⅛ yds coordinating fabric

SAMPLE QUILT
- **Ambrosia** by Jennifer Young for Benartex
- **Bella Solids White** (98) by Moda Fabrics

1 construct block

Cut (5) 2½" strips of solid fabric. Select 38 charm squares to work with. Attach the charm squares to the strip by using this modified chain piecing method:

At the sewing machine, lay a 2½" strip face up ready to sew lengthwise. Place a charm square face down on top RST, lining up the right edges. Sew a ¼" seam. A few stitches past the first square, place another down RST leaving a bit of a gap; about 8 squares per strip. Cut the sets apart, trimming away any excess fabric between each block. Press to the square.

2 cut

Cut each of the square + strip sets apart down the center at 2½."
Block: 2½" x 7"
Make: 76

1 construct block

2 cut in half

1 For quick piecing lay your squares RST on the strip and run through the sewing machine in a continuous line.

2 Trim away the excess fabric between squares.

3 Cut all the blocks in half at the 2½" mark.

4 Alternate the background square from side to side.

 TIP: *There are no seams to match in this quilt!*

3 alternate block orientation: white left, white right

3 19 blocks per column

4 add 2½" sashing

3 sew columns

Blocks are arranged in 4 vertical columns of 19 blocks each. Alternate white square to the left, white square right and so on down the row. All 4 columns have identical block orientation.

To chain piece blocks together, first set aside 12 blocks. With the remaining 64 blocks sew together lengthwise:

Sew 2 together. Yield: 32
Sew 4 together. Yield: 16
Sew 8 together. Yield: 8
Sew 16 together. Yield: 4

Return to the 12 blocks set aside. Sew 2 together 4 times. Add a single block to these 4 pairs.

Yield: 4 sets of 3 blocks.

Add one set of 3 blocks to each column of 16 blocks. Press.

Yield: 4 columns of 19 blocks.
Row size: 7" x 38½"

4 sashing

Cut (3) 2½" strips from the solid sashing fabric. Subcut to the average length of the 4 columns. Sew columns together with a 2½" wide sashing strip between each. Press toward the sashing.

Quilt Center: 32½" x 38½"

5 borders

Cut (5) 2½" strips of inner border fabric. Find the average measurement of the quilt width (measure in three places). Cut 2 strips to that size and attach to the top and bottom. **A** & **B** Press to the borders.

Repeat for the sides measuring lengthwise. Include the newly attached borders in your measurements. Cut 2 strips to the average length. Piece strips together when needed. Attach 1 border to each side. **C** & **D** Press to the borders.

Cut (5) 4½" strips of outer border fabric. Attach to the quilt in the same manner as the inner border.

6 quilt & bind

Layer quilt top on batting and backing and quilt the way you like. Square up all raw edges.

Cut (5) 2½" strips from binding fabric. Piece together end-to-end with diagonal seams, aka the plus sign method.

Fold in half lengthwise, press. Attach to your quilt raw edges together with a ¼" seam.

Turn the folded binding edge to the back and tack in place with an invisible stitch or machine stitch if you like.

Quilt size: 44" x 50"

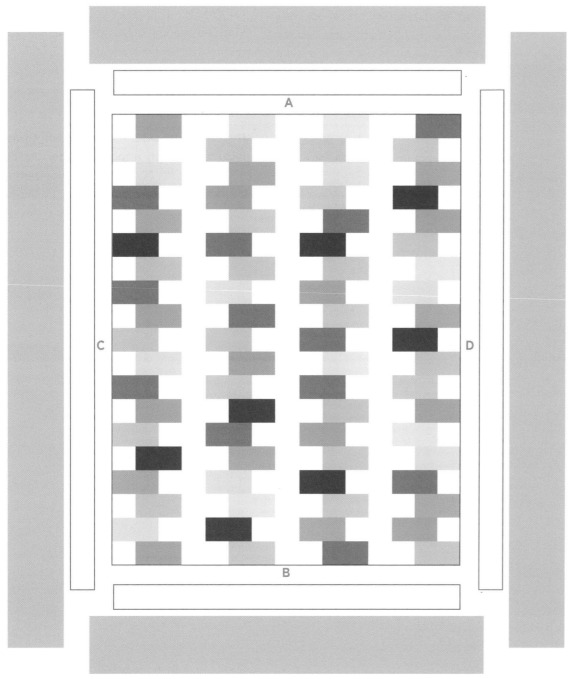

TIP: *The measurements given are not strict sizes. They are meant as guidelines only. Take the average measurements of your quilt elements before cutting sashing or borders in order to customize the cuts to your sewing.*

5 & 6 add borders

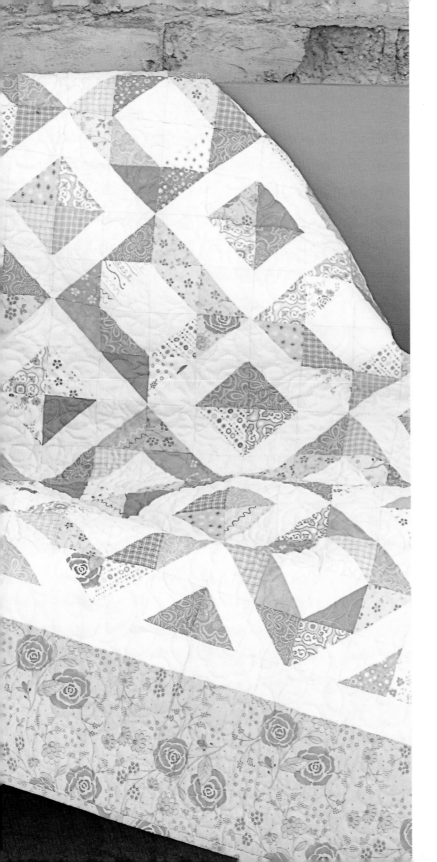

Magic Diamonds quilt

quilt designed by JENNY DOAN

I love to take a great, traditional quilt like the half square triangle and change it up a little for a fresh, modernized look. In life as in quilting, allowing tradition to evolve over time to fit your own personal style can have fabulous results! For example, the Doan family has developed some fun, unique Easter traditions that we've really come to cherish.

When I was a little girl growing up in California, we always held our Easter egg hunt on the beach near our home. But our egg hunt was a little different. None of us liked hard-boiled eggs, and we didn't hide actual treats because, on the beach, sand gets into every-thing. So we started the tradition of using eggs cut out of paper.

Each of our paper eggs was labeled with the initials of the goodie for which it could later be traded. For

33

" I love to watch the children gathered on the blankets with their mothers, their faces lit up with excitement. "

example, an egg labeled "MB" could be exchanged for a marshmallow bunny. (Of course, I was always most excited to find a paper egg with a "C" - for chocolate!) This tradition has carried on to my children and grandchildren and we all just have a great time with it.

Every Easter we all meet together at my house for the big egg hunt. Everyone brings treats to share and we all cut out and label the paper eggs together. The kids stay inside (away from the windows - no peeking!) while the adults hide the eggs in the yard. Then we spread out several quilts on the spring grass and wait for the kids to come streaming out of the house, youngest to oldest. With smiles and shouts of glee they race around the yard, hunting the eggs. My husband and I, along with the other adults, generally settle on the quilts to relax and watch the fun. When all the eggs have been found it's time to cash in the paper eggs for candy. I love to watch the children gathered on the blankets with their mothers, their faces lit up with excitement. As a mother and grandmother, this is a moment of pure joy.

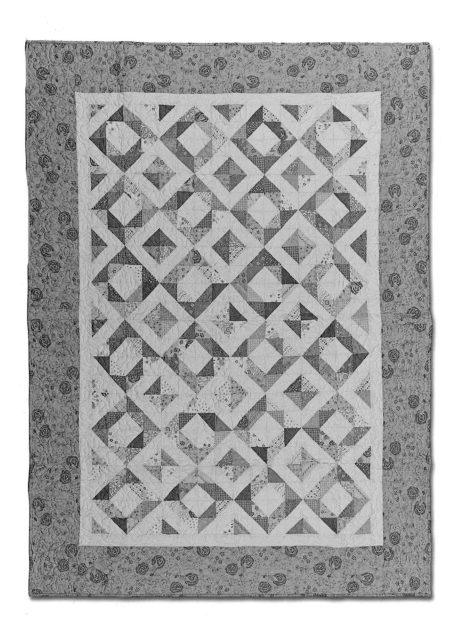

It is so wonderful to create these fun traditions with our families, and it seems like somehow a quilt is always involved. Quilts can play a quiet but important role in almost every facet of our lives, adding an element of comfort and beauty to virtually every situation. One of the most popular and versatile blocks in quilting is the half square triangle. Now we've come up with a new way to put these blocks together easily so they make a whole new pattern.

ONCE YOU'VE MASTERED the art of the half square triangle, the quilting possibilities are endless! You will be making gorgeous quilts in no time!

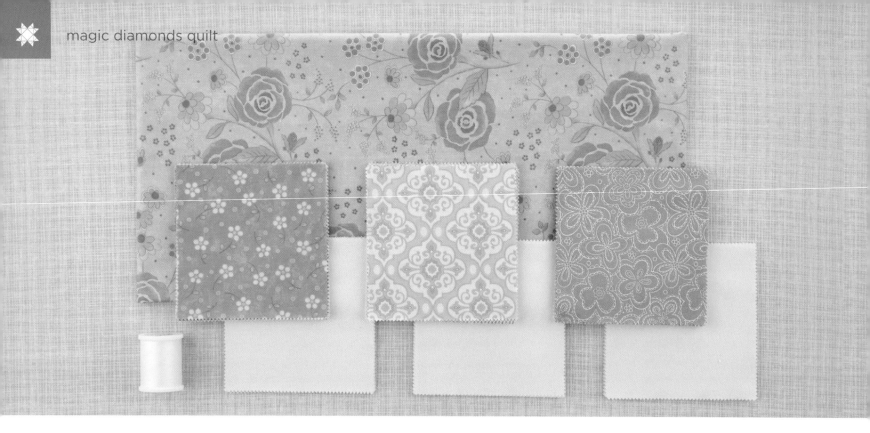

materials

makes a 59" X 79" charm pack quilt

QUILT TOP
- 3 charm packs print
- 3 charm packs solid
- ½ yd inner border solid
- 1½ yds outer border

BINDING
- ½ yd coordinating fabric

BACKING
- 3¾ yds 45" wide fabric **OR** 2 yds 90" wide fabric

TOOLS
- rotating cutting mat **OR** small cutting mat

SAMPLE QUILT
- **Chance of Flowers** by Sandy Gervais for Moda Fabrics
- **Bella Solids Snow** (11) by Moda Fabrics

1 pair up & sew

From the print charm packs use 2 entire packs plus 12 charm squares from the 3rd pack.
Total: 96 squares.

Use the same number from the solid packs. Pair up the 96 prints with solid squares RST.

Sew a ¼" around the perimeter of each pair. Cut the pair in half twice diagonally. A rotating cutting mat comes in handy, or try a small mat that can be picked up and turned between cuts. Repeat for all pairs.
Yield: (4) 3" HSTs per pair

As you press each set of 4 HSTs, set 2 into pile A; 2 into pile B.

Yield: (192) A HSTs; (192) B HSTs

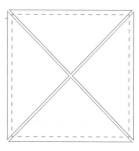

1 pair 1 solid & 1 print; stitch around the outside; cut 2 diagonals

1 Half of all the HSTs will match solid to solid with prints pointing away. Block **A**.

2 The other half of all HSTs will match print to print with solids pointing away. Block **B**.

3 Partner a Block A with a Block B: solid to solid; print to print. Yield: Block **C**.

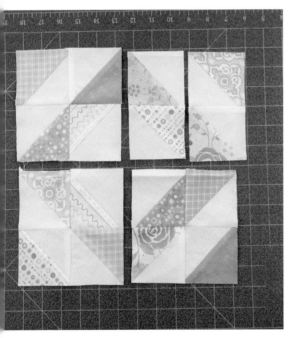

4 Arrange (4) **C** Blocks so that the solid corner faces inward.

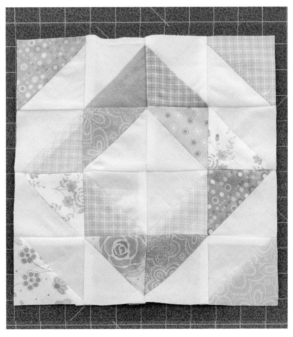

5 The final block is a patchwork square on point surrounded by white with print corners.

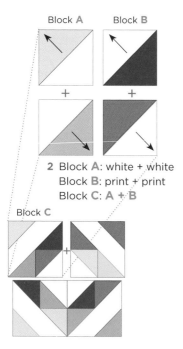

Block A Block B

+ +

2 Block A: white + white
Block B: print + print
Block C: A + B

Block C

+

2 position C Blocks so that 4 solid
corners meet in the middle
creating the diamond's center

2 block building

*Throughout the next steps, chain piece and
nest seams as you go.*

Sew all **A** HSTs into pairs, white sides
together; prints facing away.

Then sew all **B** HSTs into pairs print sides
together; white corners facing away.

Next, sew 1 Block **A** and 1 Block **B** together:
Block **C**.
Block size: 5½" x 5½"
Make: 96

Now with 4 **C** Blocks arrange them so that
4 solid corners meet in the middle.
Block size: 10½" x 10½"
Make: 24

3 quilt center

Lay out the large blocks in a 4 x 6 grid
that is pleasing to the eye. Using a
design wall, large table or floor will help
at this stage. Begin by sewing blocks
together to make rows. Press seams to
one side on even rows; to the opposite
on odd rows. Sew rows together.

Quilt center: 40½" x 60½"

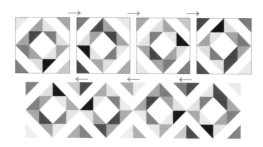

3 build rows; press seams in opposite
directions from row to row

4 borders

Cut (6) 2½" strips of background fabric
for the inner border. Measure quilt width
in 3 places and cut 2 border strips to
the average width. Attach one to the
top; the other to the bottom RST. **A & B**
Press to the borders.

Do the same for both sides, but this time
measuring the length. Include newly
attached borders in the measurements.
Piece strips together end-to-end when
needed. **C & D** Press to the borders.

For the outer border cut (7) 7½" strips.
Attach in the same manner as the inner
border.

5 quilt & bind

Layer quilt top on batting and backing and
quilt the way you like. Square up all raw
edges. Cut (7) 2½" strips of binding and
piece together end-to-end with diagonal
seams, aka the *plus sign method*. Fold in half
lengthwise, press.

Attach to your quilt raw edges together with
a ¼" seam allowance.

Turn the folded binding edge to the back
and tack in place with an invisible stitch or
machine stitch if you like.

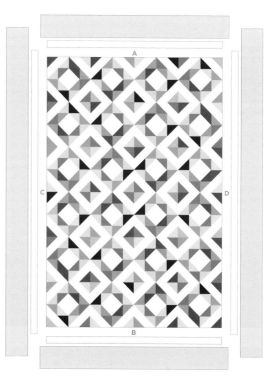

Making quilts & making friends

quilt designed by JENNY DOAN

One of the things I love most about quilting is quilters themselves! Don't you find that quilters are some of the friendliest people you meet? And when a quilter hears that you quilt too, it's like you become instant friends, which is perfect because there are just so many perks to being friends with a quilter.

For one, the gifts you get from a quilter will be handmade with love (no shoddy white elephants here). With quilters, you're pretty much guaranteed that somebody has a piece of chocolate stashed in

" When you're friends with a quilter, you always have a road-trip buddy for quilt market or a shop hop. "

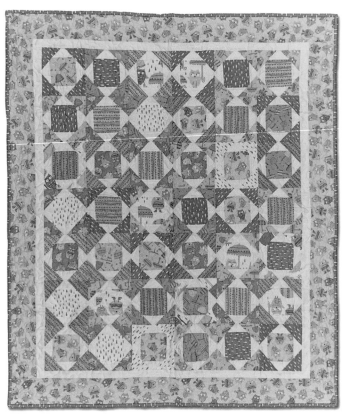

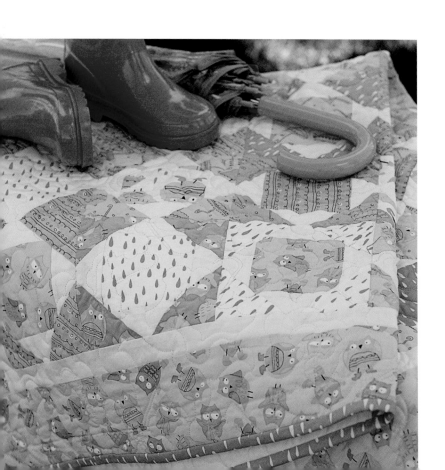

their bag in case you have a chocolate emergency. (What is it with quilters and chocolate? We may never know.) When you're friends with a quilter, you always have a road-trip buddy for quilt market or a shop hop (essential in life, don't you think?). And don't forget, only a quilter will understand your quilting-inspired nuttiness!

But perhaps my favorite thing about quilters is that they are always teaching each other and sharing the tricks and secrets they've learned.

I'm lucky because every day I reap the benefits of this quilter-to-quilter generosity. A while back I was visiting

with a lady staying at our retreat center here in Hamilton and she showed me a new block: this expanding square. I was hooked! I started making them in lots of different sizes, and I loved it because they were like little presents - every time I opened one it was a surprise!

So I set out to make a quilt with this fun, new expanding square block, but another thing about quilters (as you probably know) is that most of us don't like waste. I figure, I picked the fabric because I love it and I want to use it up! We ended up using a layer cake for this quilt and I just love the way it turned out. This kind of block is really popular right now; it's all over the quilting blogs. But this method is the easiest I've seen. And why not? At MSQC we are all about making gorgeous quilt blocks without pulling our hair out. (I'm very protective of my quilts and my hair!)

So take a bit of time and throw together this fun Economy Block. Once you learn how easy this quilt is, you'll have another trick up your sleeve to share with your quilting friends!

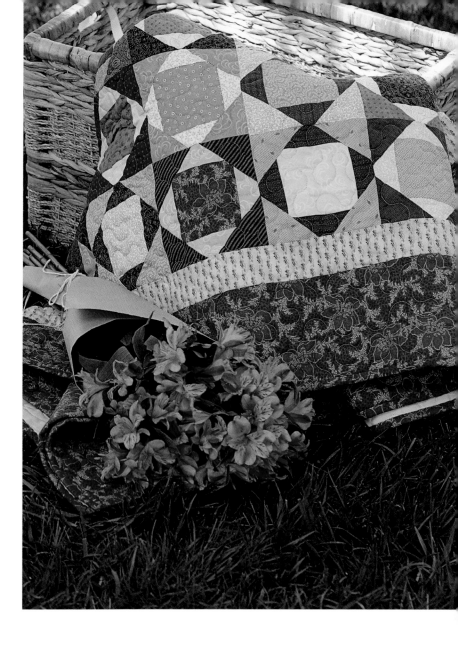

 WE LOVE THIS QUILT made up in these civil war fabrics. It just looks gorgeous in all of the many different colorways.

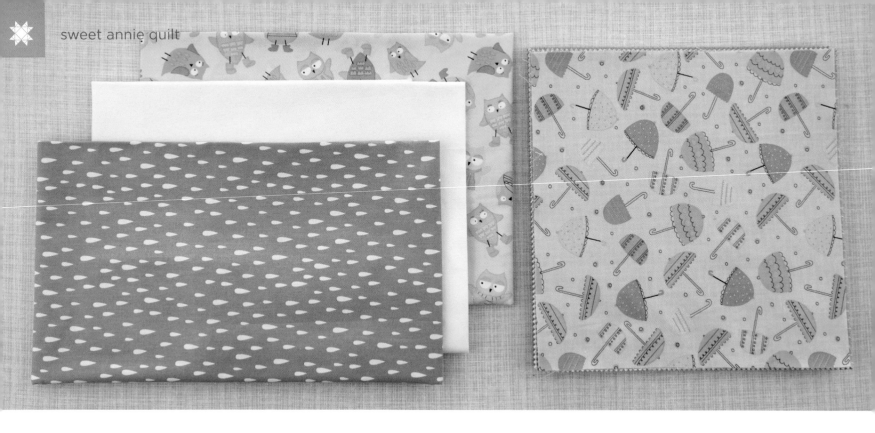

materials

makes a 42½" X 49¼" layer cake quilt

QUILT TOP
- 1 layer cake
- 1 yd background & inner border
- ½ yd outer border

BINDING
- ⅜ yd coordinating fabric

BACKING
- 1½ yds 44/45" wide

SAMPLE QUILT
- **Spring Showers** by Another Point of View for Windham Fabrics
- **Bella Solids White** (98) by Moda Fabrics

1 cut

Select 21 prints from the layer cake. Cut in half. Set half of these aside. From (21) 5" x 10" rectangles, cut in half again.

Yield: (42) 5" squares

From the other (21) 5" x 10" rectangles, trim to 4" x 10." Subcut into (2) 4" squares.

Yield: (42) 4" squares

From the background fabric cut (5) 4" strips. Subcut into 4" squares.

Yield: (42) 4" background squares

2 sew

Start with (2) 4" squares: 1 print & 1 background. RST sew around the perimeter.

1 cut each layer cake into (2) 5" squares & (2) 4" squares

2 sew ¼" around the outside

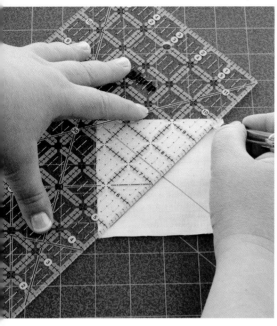

1 Draw 2 lines diagonally across the background square.

2 With scissors cut only the white background fabric up to the stitching.

3 Now use a 5″ square and repeat the process. This time cut the 5″ square diagonally.

4 Trim away the excess fabric.

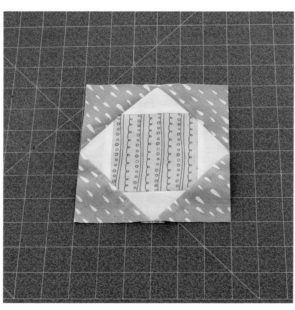

5 Completed expanding block.

3 mark diagonals
with a pencil

3 cut through one layer
along lines

4 frame again with a 5″ square;
note the corners are meant to
be cut off.

You can either sew off each end or pivot and turn. It makes no difference. Make 42.

3 mark & cut

With a marking pencil and ruler draw 2 diagonal lines from corner to corner on the background square. Use scissors to cut on the lines through one layer of fabric only. Set with the iron and press open. You now have a square-in-a-square. Make 42.

4 frame again

The 5″ squares will now be used to frame the square-in-a-square again. Proceed exactly as in step 3 except that you will use the 5″ square as your guide for a ¼″ seam allowance. The square-in-a-square will be slightly smaller than the 5″ square, but the larger square is geometrically correct so that is the square we use as a seam guide. Repeat steps 2 & 3 marking and cutting the 5″ square. Set with the iron and press open. Repeat 42 times.

Block size: 6¼″ x 6¼″

5 quilt center

Lay out the quilt center in an eye-pleasing 6 x 7 grid. Attach blocks to each other side to side to create rows; then sew rows together to make the quilt center. Follow the pressing arrows. This will help in nesting seams when rows are sewn together.

Quilt center: 30″ x 40¾″

6 borders

Cut (4) 1½″ strips of background fabric for the inner border. Measure quilt width in 3 places and cut 2 border strips to the average width. Piece strips together when needed. Attach one to the top; the other to the bottom RST. **A** & **B** Press to the borders.

Do the same for both sides, but this time measure the length in 3 places. Include newly attached borders in the measurements. Piece strips together end-to-end when needed. **C** & **D** Press to the borders.

For the outer border cut (5) 3½″ strips. Attach in the same manner as the inner border.

7 quilt & bind

Layer quilt top on batting and backing and quilt the way you like. Square up all raw edges.

Cut (5) 2½″ strips of binding and piece together lengthwise with diagonal seams, aka the *plus sign method.* Fold in half lengthwise, press. Attach to your quilt raw edges together with a ¼″ seam allowance.

Turn the folded binding edge to the back and tack in place with an invisible stitch or machine stitch if you like.

Quilt size: 42½″ x 49¼″

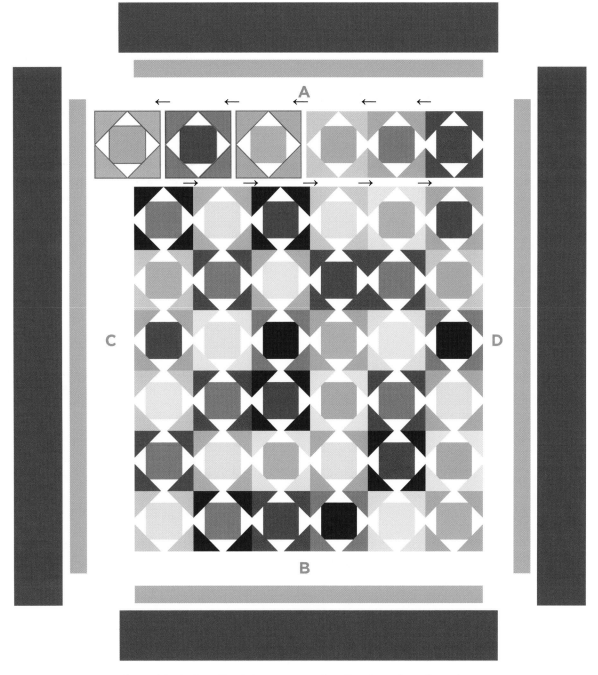

4 sew blocks together into rows; rows together to make quilt center
5 add inner and outer borders

Dresden
Coin Quilt

quilt designed by NATALIE EARNHEART

There's just something about a precut - the carefully coordinated pieces stacked flawlessly, the sharp, pinked edges, all wrapped up with a ribbon like a birthday present. The whole thing just feels so freshly minted. It can be a little scary to unwrap such an intimidatingly perfect little bundle and start cutting. (It's not just me, right? Tell me I don't need to discuss this with my therapist!)

But then you finally do it; you find the perfect pattern and take the leap. You plan, cut, arrange, sew, press, and sew (and sew and sew and sew and....) You quilt, bind, and fall in love! You experience Quilter's Rush— the exhilaration that comes from having actually completed a project and not leaving it in the closet half-finished. And then you find another irresistible precut and the cycle continues. It's sort of like the Circle of Life.

Sadly, though, it's rarely that straightforward. Instead of the Circle of Life, my own quilting process is more like the Drunkard's Path of Life! Seams don't match, sewing machines won't cooperate, and plenty of unpicking ensues, not to mention the time it takes to complain to my quilting friends about all the problems I'm having! Indeed, one of my biggest time-eaters during a project is repeating to myself the mantra, "It will be beautiful. Just don't throw it out the window before it's finished and it will be beautiful!"

However, not all side roads on my quilting journey are bad. In fact, my favorite messy little thing about quilting is scraps! I have to admit, I'm a compulsive scrap collector and I can't be satisfied until I use up all of the scraps after a project. This can be a problem, to put it mildly.

You know how it is when you finish a project. You start a second quilt with the leftovers but you have to buy more to finish that one, leaving you more leftovers to start a third quilt, but then you run out again so you have to buy even more to finish that one! But that's ok because you can just pick up some more fabric on your way to the loony bin

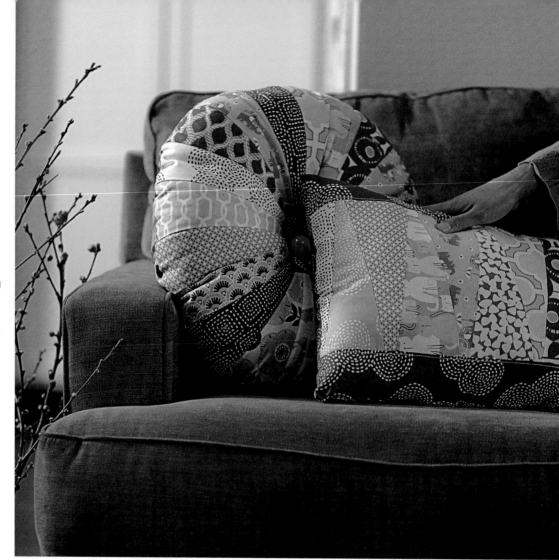

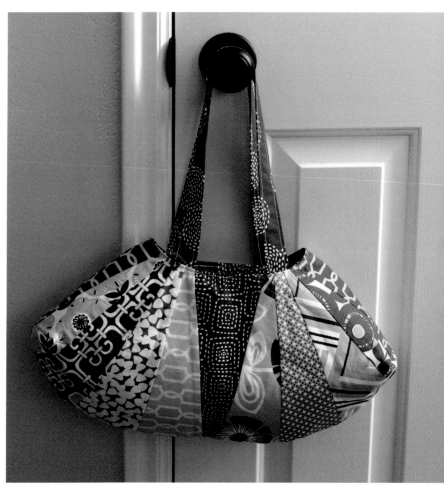

because by now you've begun to lose your mind! I call this problem the Vicious Circle of Life!

So, of course, when there were lots of Dresden pieces left after the completion of the Dresden Coins quilt, I couldn't stop there. So I made a pillow. And a second pillow. And then a purse. (There were lots of leftovers!) And finally, not only could I rest easy knowing all of the leftovers were used, but I had enough finished projects for a bedroom makeover!

THIS QUICK AND EASY BAG is a perfect project for a beginner! It goes together in a snap, and looks adorable! Make one for yourself and one for a friend!

51

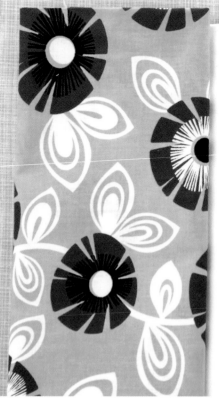

materials

makes a 76" x 80" layer cake quilt

QUILT TOP
- 2 layer cakes
- 1¼ yds solid for sashing & 1st inner border
- ½ yd 2nd inner border
- 1¼ yds outer border

BINDING
- ⅝ yd coordinating fabric

BACKING
- 5 yds 44" wide fabric OR 2¼ yds 90" wide fabric

TOOLS
- MSQC 10" Dresden Plate Ruler

SAMPLE QUILT
- **Pastel Pops Citron** by Michael Miller Fabrics
- **Bella Solids White** (98) by Moda Fabrics

1 select & cut

This quilt requires 1 entire layer cake plus 12 from the second layer cake: total 54 squares.

Use the MSQC Layer Cake Dresden Plate Ruler to cut 3 wedges from each 10" square—although 2 will not be needed. Make sure to flip the shape as you cut the strips—it's quicker and saves fabric too!
Yield: 160 wedges.

2 chain piece

Chain piecing is a quick method of sewing blocks together. Layer 2 wedges RST thin end matching thick end. Make sure they are offset at your

1 cut wedge shape: 3 per layer cake

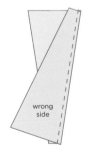

2 offset the wedges at the ¼" seam allowance RST

¼" sewing line. Feed the pair through the sewing machine. Continue sewing off the fabric a few stitches and feed the next pair through the machine and so on.

Snip threads to separate blocks. Press to the dark side. Next sew 4 together, then 8, 16 & 32. Stop when you have (5) 32 coin strips completed.

3 straighten

Straighten both ends of each coin strip with the Dresden Plate Ruler. Match the center line on the ruler to the last seam. Be careful to place the ruler correctly—it faces the same direction as the last wedge. Cut to straighten.

4 sashing

Cut (7) 3" strips of sashing fabric. Measure the length of the 5 coin columns. Cut (4) strips to the average length, piecing strips together when needed. Sew sashing strips between all 5 coin columns. When working with sashing and borders, keep the sashing on top as you sew to avoid the ruffling action of the sewing machine's feed dogs. Press to the sashing.
Quilt center: 58" x 62"

5 borders

Cut (7) 3" strips of sashing/inner border fabric. Find the average measurement of the quilt width (measure in three places). Piece strips together to attain the size needed. Cut 2 strips to that size and attach 1 to the top and 1 to the bottom. **A & B** Press to the borders.

Repeat for the sides measuring lengthwise. Include the newly attached borders in your measurements. Sew borders to each side. **C & D** Press to the borders.

In the same fashion, attach the second inner border. Cut (7) 2" strips of fabric.

For the outer border cut (8) 5" strips of fabric and attach in the same manner as the previous borders.

6 quilt & bind

Layer quilt top on batting and backing and quilt the way you like. Square up all raw edges.

Cut (8) 2½" strips from binding fabric. Piece together end-to-end with diagonal seams, aka the plus sign method.

3 straighten the first and last wedge of each coin strip using the Dresden Ruler

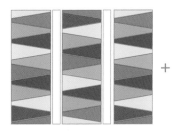

4 sew sashing between coin columns

Fold in half lengthwise, press. Attach to your quilt raw edges together with a ¼" seam.

Turn the folded binding edge to the back and tack in place with an invisible stitch or machine stitch if you like.

 HAVING TOO MUCH FUN with this project? Great! Because there is extra fabric left over to make a purse and two pillows!

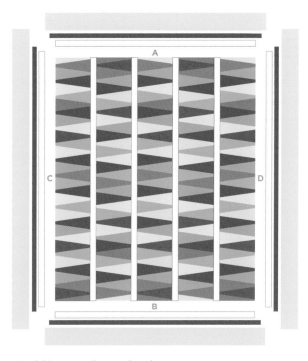

4 add inner and outer borders

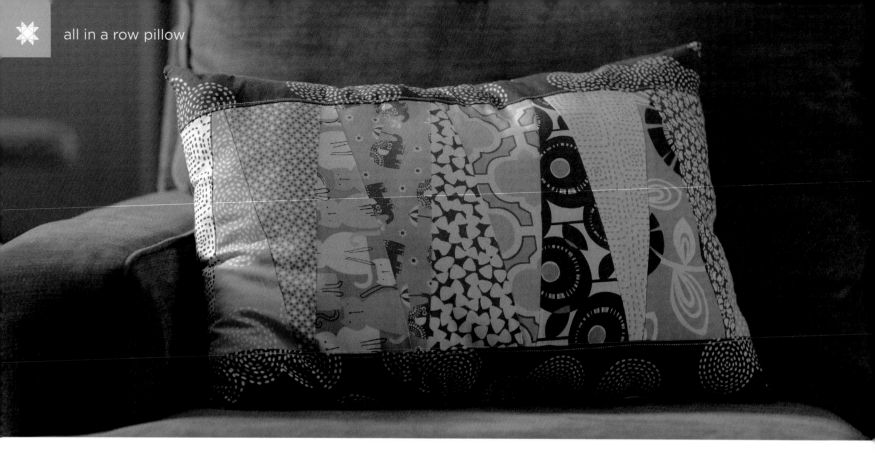

all in a row pillow materials

DRESDEN PILLOW
- 11 leftover Dresden Plate wedges from Dresden Coin Quilt project
- ½ yd backing

TOOLS/EXTRAS
- MSQC 10" Dresden Plate Ruler polyester stuffing

SAMPLE PILLOW
- **Pastel Pops Citron Grey** by Michael Miller Fabrics

1 select & cut

For this project you may have leftover Dresden Plate wedges from making the Dresden Coin Quilt. Select 11. If not, use the MSQC Layer Cake Dresden Plate Ruler to cut 11 wedges.

It's up to you if you'd like use all different fabrics or just a few repeated. Plus, you can decide how long you'd like your pillow to be. It's up to you! It may help to know that each layer cake renders 3 Dresden Plates.

2 pillow front

The front panel consists of a row of wedges sewn together side-by-side and two strips framing the row lengthwise.

1 cut wedge shape: 3 per layer cake

wrong side

2 offset the wedges at the ¼" seam allowance RST

Start by sewing wedges together to create a row. Alternate the wedge orientation: up, down, up down. RST offset the wedges at the ¼" seam allowance matching wide to narrow sides. Sew 10 together.

3 ends

Use the Dresden Plate ruler to cut 1 Dresden Plate in half. These halves will complete the row and make a rectangle. Line up the ruler's center line with one side of the wedge. Make sure the ruler and the wedge are pointing in the same direction. Cut.

Attach these half-wedges to the ends of the row. Be careful to sew along the angled edge—you want the straight side of the half-wedge to finish the row. Press.

4 top & bottom

Cut (1) 3½" strip of backing fabric. Measure the length of the Dresden Plate row and subcut the strip to that size. Make 2.

Attach 1 strip to the top; the other to the bottom of the Dresden row. Press to the strips. Topstitch about ⅛" from the seam on each strip.

5 pillow back

Use the completed pillow front as a pattern to cut a backing from the yardage.

Lay front and back RST. With pins, mark about a 7" opening on one of the short ends. Start by backstitching at a pin; sew

all around the pillow. Backstitch again as you reach the second pin. Clip the corners. Turn right side out. Push the corners out. Press.

At the opening, turn the seam allowance to the inside and hold it taut as you iron. This will give you a sewing line to use when you hand stitch the opening closed.

6 finishing

Use polyester stuffing to fill the pillow. With needle and thread close the opening shut using an invisible stitch.

3 cut the last wedge in half using the Dresden Ruler

3 complete the row by adding half-wedges to each end

4 add strips to top and bottom; topstitch

wrong side

5 use the pillow front as a pattern for the back; sew front to back leaving an opening

5 clip corners of excess fabric

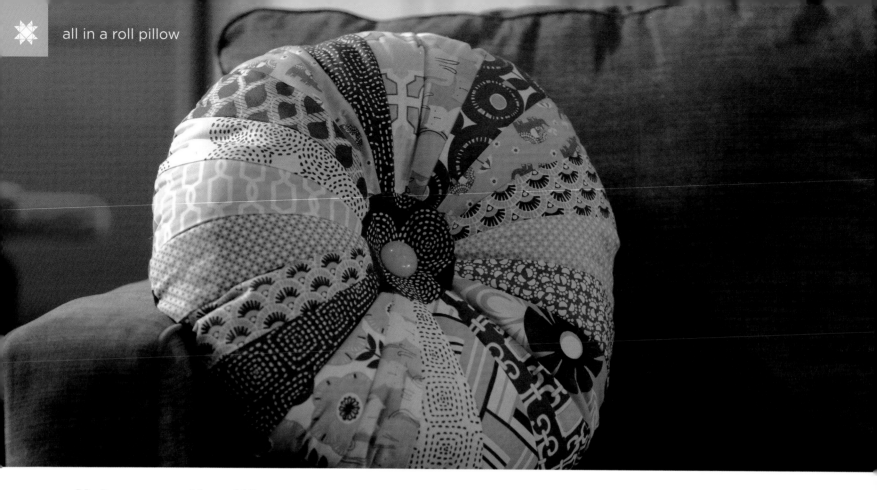

all in a roll pillow materials

PILLOW
- 20 leftover Dresden Plate wedges from Dresden Coin Quilt project
- ¾ yd backing

TOOLS/EXTRAS
- MSQC 10" Dresden Plate Ruler
- Polyester stuffing
- 1 large coordinating button
- Heat 'N Bond

SAMPLE PILLOW
- **Pastel Pops Citron Grey** by Michael Miller Fabrics

1 select & sew

Select 20 Dresden Plate wedges from a previous project, or, cut them out of layer cakes using the MSQC Dresden Ruler.

Sew the wedges together, matching wide ends. Chain piecing the wedges will speed up the process.

2 pillow center

To cover the hole in the center of the pillow top, find a bowl, lid or any round object that you can use as a circle template. Use the object to trace a circle onto *Heat 'N Bond*. Cut beyond the traced line. This center circle and the pillow back will be the same fabric.

1 sew all 20 wedges together; chain piecing makes this step faster

Make sure the bumpy texture is against the wrong side of the fabric. Press to activate the adhesive. Cut out on the line.

Position the circle over the center hole by eyeing its placement. Before pressing lay paper underneath the hole to protect your ironing board from the adhesive. Press into place.

Stitch along the edge of the circle with either a straight, zig-zag, buttonhole or satin stitch.

3 pillow back

Use the pillow top as a pattern to cut the backing fabric.

Sew the top to the back RST. Leave a 4"-6" opening. Backstitch on both sides of the opening. Turn right side out.

4 stuff & finish

Fill the pillow with stuffing.

Close the opening by handstitching. Turn the seam allowances toward the inside as you slipstitch, catching the folded edges with your needle.

5 attach button

To attach the button to the pillow first double your thread. When you thread your needle you will have 4 strands total. Knot the end. Starting at the back push the needle through the back and stuffing up through the center of the pillow front. At this point do not pull the thread taut. Attach the button to the center, making as many stitches as you need. Then push the needle back through the pillow and out the bottom again. Grab the thread's knot and tie all 8 thread strands together pushing toward the pillow to create an indentation. Clip threads leaving a short 1" tail.

2 stitch around the edge of the circle

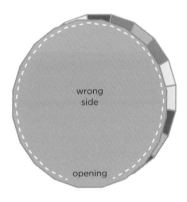

wrong side

opening

3 sew top to bottom; leave an opening

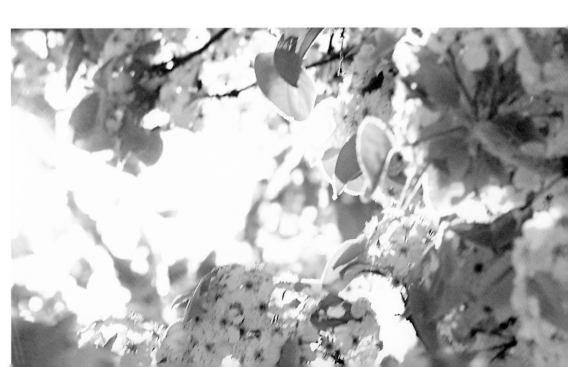

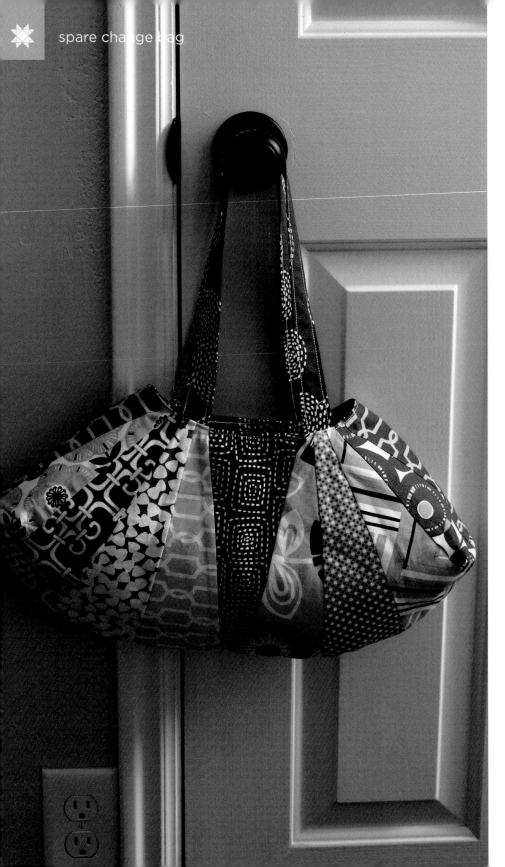

spare change bag materials

BAG
- 1 layer cake
- ¾ yd lining & handles

INTERFACING
- 2 yds Pellon shape flex 101
- fusible woven interfacing

TOOLS
- MSQC 10" Dresden Plate Ruler

SAMPLE BAG
- **Pastel Pops Citron Grey** by Michael Miller Fabrics

1 select & cut

Use the MSQC Layer Cake Dresden Plate Ruler to cut 22 wedges. Each side of the bag consists of 11 wedges. It's up to you if you'd like use all different fabrics or just a few repeated. It may help to know that each layer cake renders 3 Dresden Plates.

2 outer panels

The bag's exterior is made with 2 panels. Each panel has a center wedge pointing down, 2 sections of 4 wedges all pointing up that flank either side of the center wedge and two additional wedges at the ends that point down and are cut in half.

Begin by piecing the 4-wedge sections together. All points face in the same direction. Make 4.

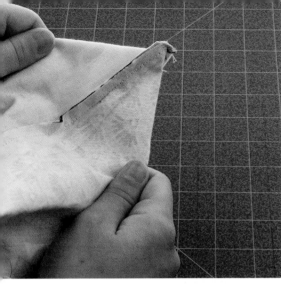

1 To make the gusset, line up the bottom and side seams of the bag.

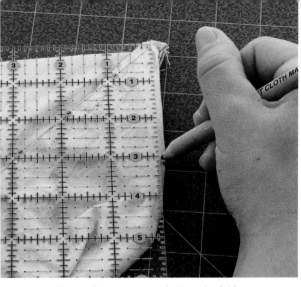

2 On each side of the gusset mark 3″ on the fold.

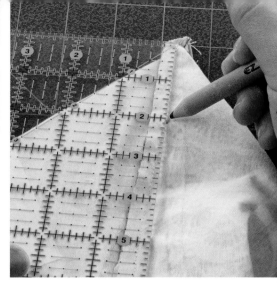

3 Mark 2″ down the center of the seam.

4 Insert the outer bag inside the lining RST.

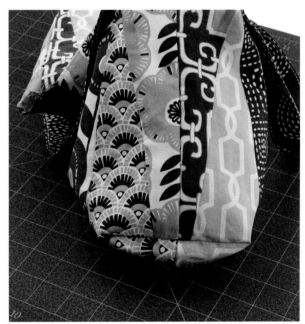

5 After turning the bag right side out, gently push out the gusset. See how the bottom and side seams match.

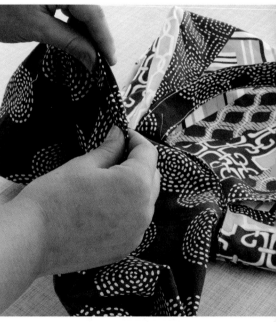

6 To close the opening, fold the seam allowances in and tug at either side. Press and topstitch very close to the folded edge backstitching at both ends.

1 you can cut up to 3 wedges per layer cake

2 piece together the 4-wedge section

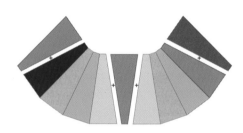

2 sew (2) 4-wedge sections to either side of the center wedge; add final wedges to the ends

3 straighten the first and last wedge using the Dresden Ruler

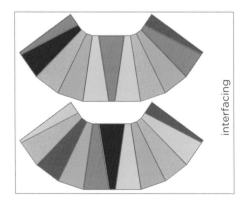

4 use the bag panels as patterns to cut out interfacing

interfacing

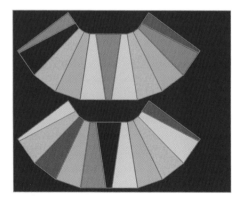

4 use the outer bag panels as patterns to cut out lining as well

Add a 4-wedge section to either side of a center wedge that points down.

Add the final wedges to the ends. Make sure these point down.

3 trim

Use the Dresden Plate ruler to trim the ends on both panels. Line up the ruler's center line with the last sewn seam. Make sure the ruler and the wedge are pointing in the same direction. Cut. Press seams toward the outer edges.

4 cut

Use the outer panels as patterns. Cut out interfacing for each. Adhere the interfacing to the wrong side of each panel. Make sure the bumpy texture is against the fabric. Press.

From the lining fabric cut a 4½" strip and set aside for the handles. Again use the outer panels as patterns but this time cut 1 lining panel for each outer panel. These are the inner panels.

Then use the lining as a pattern cut interfacing for both. Adhere interfacing to each lining.

5 sew outer panels

From now on all seams are backstitched at the beginning and end.

With fabric panels RST sew both sides and the bottom closed. Backstitch at the begining and end. **5A**

To form the gussets open the seam flat and match the side to the bottom seam at the corner. From the corner's tip mark 2" down the center and at 3" on the folded sides. Use a pencil to connect those points. Sew

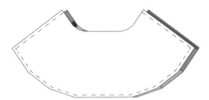

5A sew bag panels together

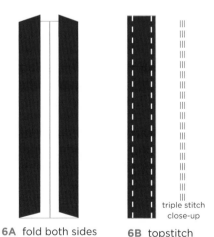

5B make the gusset

6A fold both sides to the center; fold closed

6B topstitch

triple stitch close-up

along this line backstitching at the beginning and end. **5B** Trim to a ¼." Turn right side out. Gently push out corners.

6 handles

Use the 4½" strip cut from the lining fabric to make bag handles. Keep the strip folded. Remove the selvages and the fold: (2) 20" strips. Fold in half lengthwise and press. Open up and fold both sides into the center fold. Press. Close the first fold again. There are now four layers. **6A**

Select triple stitching and topstitch about ⅛" along both lengthwise edges. **6B**

One handle is positioned onto each outer panel. Place the raw ends of the handle along the top edge of the outer panel. Align the inner fold of the handle to either side of the center wedge. Careful not to twist as you position it. Stitch ¼" from the top edge to secure the handles in place. **6C**

7 lining

Sew the lining together in the same manner as the purse panels except this time leave a 4" opening along the bottom for turning.

Make the gussets as in **5B**. Do not turn the lining inside out.

8 sew together

Set the completed outer panel of the bag inside the lining that is still wrong side out. They should be RST. Push the handles down between the two layers keeping them out of the way. Match raw edges along the top opening. Make sure to line up the side seams. Pin together and sew ½" from the top all around.

Pull bag through the opening in the lining.

9 finishing

To permanently close the opening, tuck the seam allowances to the inside and tug both sides of the hole. Press along the folds that are created. At the sewing machine topstitch along the fold close to the edge. Make sure to backstitch at both ends. Push the lining into the bag pushing out the sides and bottom. Pull the handles up.

Roll the lining at the top opening slightly to the inside; press, then topstitch along the edge about ⅛." If you want, use the triple stitch.

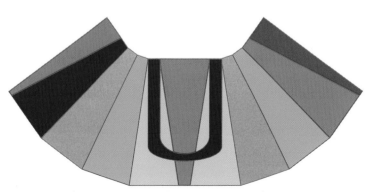

6C attach handles to either side of the center wedge

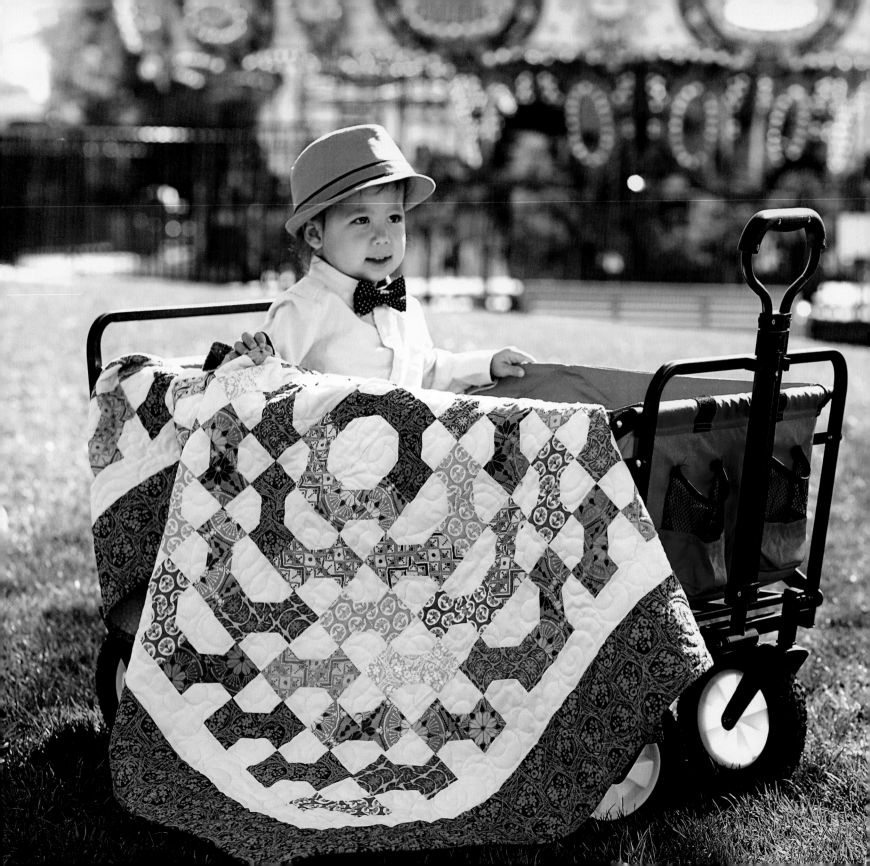

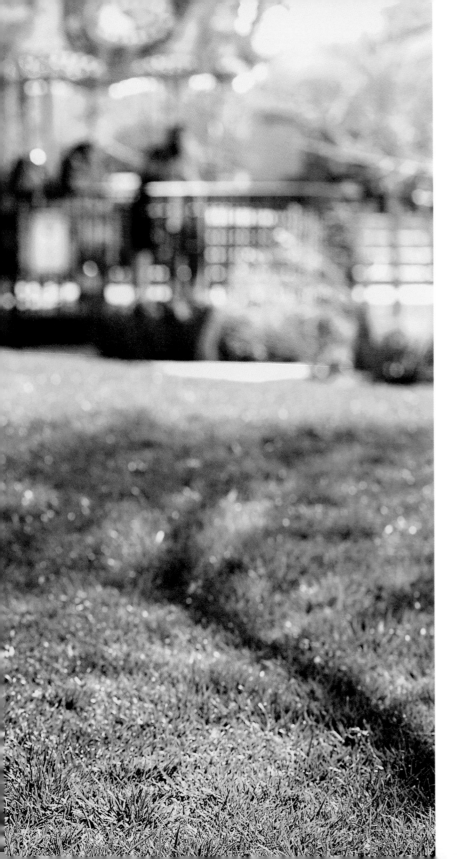

Bowtie Party Quilt

quilt designed by JENNY DOAN

I have always loved antique quilts. I love to imagine the quilter, many years ago, carefully piecing and stitching together their fabrics. I just think it is amazing to see the beautiful, intricate patterns they were able to create without the aid of fancy rulers, rotary cutters, precuts, and often even without sewing machines! I love my precuts and all the time-saving conveniences of modern day quilting, but I truly admire the time and talent required in the past to create some of these magnificent quilts. These quilters were real artists, and their handiwork is just as beautiful today as it was a century ago.

One of my favorite antique quilt patterns is the bowtie quilt. This love affair began years ago when a good friend brought in a bowtie quilt to be machine quilted. The bowties were adorable and tiny. The fabric was scrappy and the background was a bright shade of cheddar. The quilt was breathtaking and I completely fell in love with it.

Right away, I started thinking about how to simplify making the bowtie quilt so I could share it with all of you. I decided to make it a bit bigger than normal so that I could use a pre-cut charm pack, and the outcome was stunning! One of the most amazing things about this

63

quilt is the many ways to lay it out. Just by turning the blocks you get a whole new look!

Over the years, I have made several bowtie quilts and I never get over how beautiful they always turn out. This brings to mind the image of little boys all dressed up in their Sunday best for church, their faces scrubbed clean and their hair carefully combed and parted. It's not often you see a little boy looking so neat and tidy!

In our family of seven kids, we were blessed with four boys. No one knows better than I do how quickly a little boy can get into some kind of mischief and end up covered head to toe in dirt. Perhaps that's the reason I find the idea of a tidy little man all decked out with a bowtie so charming! When the kids were young, I always did my best to make sure the whole gang was groomed nicely for church, but sometimes it was all I could do just to get us out the door on time!

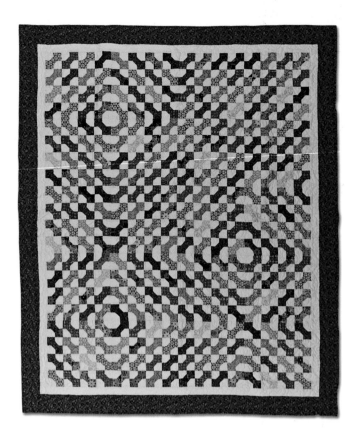

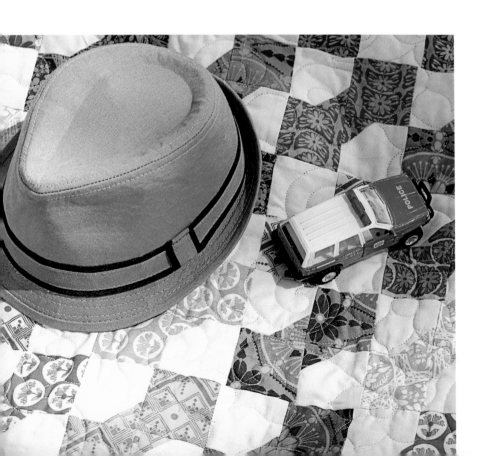

However, Easter Sunday was different. It was just such a special day for us. I loved picking out pretty new dresses for the girls in springtime pastels. The boys had freshly pressed white shirts and maybe a new tie or pair of slacks. I just wanted them to look as clean and special as possible on such a sacred day.

Easter Sunday has always been one of my favorite days of the year. It just feels so sweet and clean. The celebration of fresh starts and hope is echoed in the changing season. After a long, hard winter, the earth has finally started to thaw and become green and vibrant once again. Reimagining an old, traditional quilt pattern perfectly reflects that theme of old things becoming new again, making this antique-inspired bowtie the perfect quilt for a beautiful Easter Day celebration.

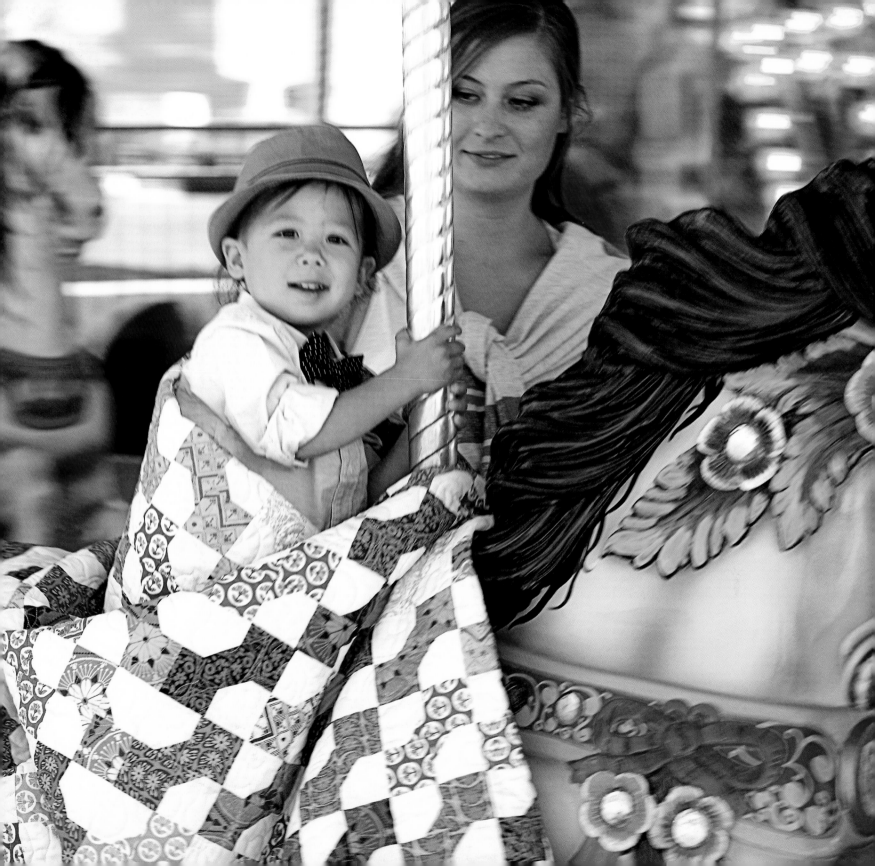

materials

makes a 77" X 93" charm pack/jelly roll quilt

QUILT TOP
- 8 charm packs
- 1 jelly roll background solid
- ½ yd background solid
- 1¼ yds outer border

BINDING
- ⅔ yd coordinating fabric

BACKING
- 5½ yds 44" wide fabric
- 2⅓ yds 108" wide backing

SAMPLE QUILT
- **True Colors** by Anna Maria Horner for Free Spirit Fabrics
- **Bella Solids Snow** (11) by Moda Fabrics

1 cut

Cut (640) 2½" squares from 38 background solid jelly roll strips.

From 320 charm squares cut:

 (2) 2½" squares

 (2) 1½" squares

From the 8 charm packs there will be 16 charm squares left over.

2 snowball

To snowball a corner use the small 1½" print square and lay it RST on the 2½" solid background square. Sew diagonally across the print square. trim off all but ¼" seam allowance. Press open.

Chain piecing will speed up the sewing process. Simply run all the pairs through the sewing machine assembly-line fashion. Sew across the small square. Make a couple stitches off the fabric and be ready with the next pair and so on. Clip threads to separate; trim all the pairs; then press all of them.

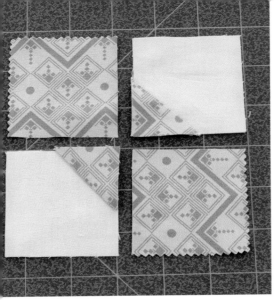

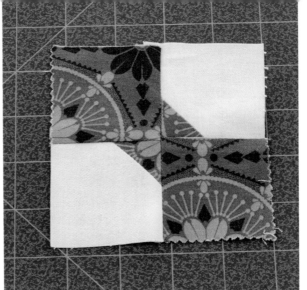

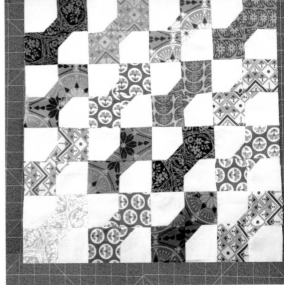

1 Each bowtie consists of 2 print squares and 2 background squares with snowballed corners.

2 One bowtie block.

3 Bowtie blocks all facing the same direction create the 16-patch block.

| 1½"
x
1½" | 1½"
x
1½" |
| 2½"
x
2½" | 2½"
x
2½" |

1 cut (2) 2½" and (2) 1½" squares from a print charm square

2 snowball the background square with a 1½" print square

3 make bowties

Make a bowtie using (2) 2½" squares and 2 snowballed background squares with the same printed fabric. Arrange the snowballed corners so they face across and toward each other. Sew top row; then bottom row. Press toward the large print square. Sew both rows together nesting the seams.

Yield: 1 block
Make: 320

4 16-patch

Select 16 bowtie blocks to make one full-sized block. Arrange into a 4 x 4 grid. Keep all the bowties angled in the same direction. Sew bowties together in rows first, pressing seams to one side on the first row, to the other side on the second row and so on; then sew 4 rows together to complete the block, nesting seams as you sew.

Make: 20

5 quilt center

Arrange the 20 blocks in a 4 x 5 grid. Notice the various patterns that emerge when the blocks change orientation. When you are satisfied with your creation begin sewing blocks together in rows; then rows together to make the quilt center: 64½" x 80½"

6 borders

In addition to the 2 remaining jelly roll strips, cut (6) 2½" strips of background fabric for the inner border. Measure the width of the quilt in 3 places: top & bottom edge and through the middle.

Cut 2 strips to the average of those measurements, piecing strips together when needed. Stitch 1 strip to the top edge RST; and 1 to the bottom edge. **A & B** Press to the border.

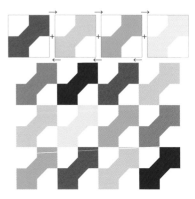

4 build the 16-patch

Next measure the quilt in 3 places lengthwise. Include the newly attached borders. Take the average. Cut 2 strips to that length, piecing strips when needed. Attach one to each side. **C & D** Press to the borders.

For the outer border cut (9) 4½" strips. Measure, piece, cut and attach in the same manner as the inner border.

7 quilt & bind

Layer quilt top on batting and backing and quilt the way you like. Square up all raw edges.

Cut (9) 2½" strips of binding and piece together end-to-end with diagonal seams, aka *the plus sign method*. Fold in half lengthwise, press. Attach to your quilt raw edges together with a ¼" seam allowance.

Turn the folded binding edge to the back and tack in place with an invisible stitch or machine stitch if you like.

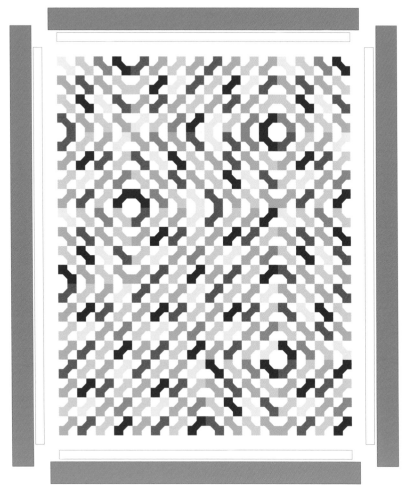

5 create the quilt center
6 add borders

Mini House
table runner

quilt designed by JENNY DOAN

Mormor is the Swedish word for "mother's mother," or "grandmother." My maternal grandfather passed away before I was born, so my own Mormor lived with us all while I was growing up. I felt so lucky to have the benefit of two mother figures to care for me and love me. Together, Mom and Mormor created an environment of goodness and warmth that filled my childhood with happiness and fun. They were both amazing cooks and there were always goodies and yummy snacks available. (I am of the opinion that we will all eat homemade Swedish rolls in heaven.)

So often love is expressed with good food and time spent around the table. To this day, whenever I get to missing my sweet Mormor, I get out her famous apple cake recipe and head to the kitchen. Those first few whiffs of cinnamony goodness wafting from the oven take me right back to the happy days I spent learning to bake at her side.

Experts say that grandparents can be one of the greatest influences in a child's life. Grandparents have so much love and wisdom to share with their little ones, and often aren't as burdened as parents by the hustle and bustle of every-day life. I know no one could make me feel as special as my Mormor could. She just knew me so well and could see the good in me even when it was hard to see it for myself. She was patient, happy, and full of optimism. I hope that over the years I have been able to develop some of the charac-teristics that I so cherished in my sweet grandmother.

THIS TABLE RUNNER LOOKS GREAT in solids as well as prints! Create your own neighborhood out of your favorite fabrics!

𝒜pple 𝒩ut 𝒞ake recipe by Ingrid Nystrom

1½ cups salad oil	Mix oil, sugar, and eggs. Sift dry
2 cups sugar	ingredients, stir into oil mixture (will
2 eggs, beaten	be dry). Pour into greased 13½ x 18½
3 cups flour	cake pan. Bake at 375° for 40 min. or
1 tsp. salt	until cake pulls loose around edges.
1 tsp. soda	Serve warm or cold. A good recipe to
¼ tsp. cinnamon	cut into bars and freeze for lunches.
3 cups apples - peeled and diced	
½ cup chopped nuts	
½ cup raisins	

"...grandparents can be one of the greatest influences in a child's life."

In choosing fabric for this table runner, I thought it would be fun to use the Mormor fabric as a tribute to my grandmother and the tremendous impact she had on my life. Each block is like a little Swedish house, and I am reminded of my own childhood home where love (and good food!) always abounded.

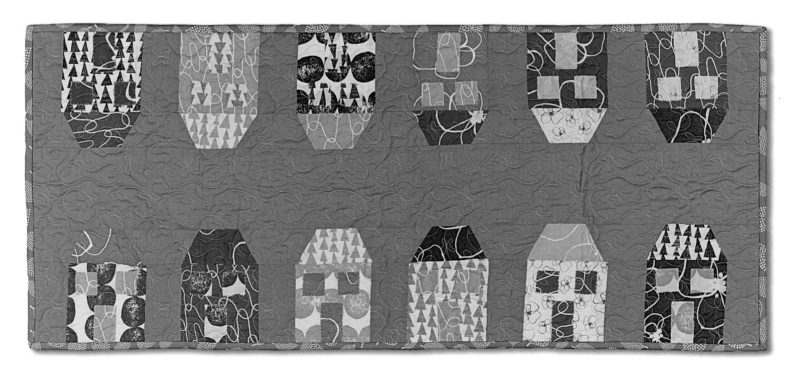

materials

makes a 18½" X 44¼" charm pack runner

TABLE RUNNER
- 1 charm pack print
- ½ yd background solid

BINDING
- ⅓ yd coordinating fabric

BACKING
- 1⅜ yd coordinating fabric

EXTRAS
- Heat 'N Bond
- 5" Half Hexagon Ruler

SAMPLE QUILT
- **Mor Mor** by Lotta Jansdotter for Windham Fabrics

1 windows & doors

Adhere *Heat 'N Bond* to the back of 3 charm squares. This will make enough windows and doors for 12 houses.

Following the diagram, cut the 3 squares down the middle vertically and again horizontally.
Yield: (12) 2½" squares

Out of each 2½" square you will make 1 door and 2 windows. Cut the 2½" square in half once. Cut only one side in half again.
Yield: 12 doors; 24 windows

2 build the house

Remove the *Heat 'N Bond* paper and lay the door and windows on a printed charm square. Press to set. Make 12 houses.

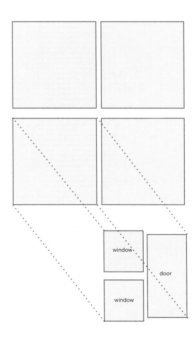

1 make windows & doors

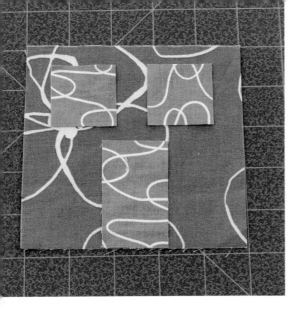

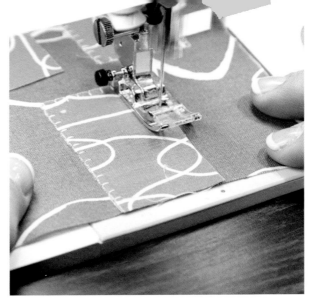

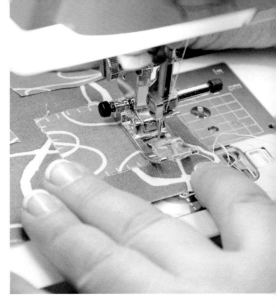

1 Each ¼ charm square makes 1 door and 2 windows for a house.

2 Stitch around each door and window.

3 Use a straight, zig-zag, buttonhole or tacking stitch.

2 build the house

3 make a street

fold

4 cut shapes from a folded 5″ charm square

Stitch around each door & window using either a zig-zag, buttonhole, straight or tacking stitch. Handstitching is also an option.

3 make a street

Cut (2) 2¾″ strips from the background solid fabric. Subcut into (14) 5″ rectangles. These will be the side yards between each house.

To build a street, start with a side yard and sew it to left side of a house. Alternate between side yard and house until there are 6 houses on the street. End with a side yard. Make 2 streets.

4 a roof overhead

You will need 6 print charm squares and (7) 5″ solid squares to build the rooftops and sky. Cut (1) 5″ strip of the background solid fabric; subcut into (7) 5″ squares. Using the Half Hexagon Template Ruler, fold a square in half, align the short side of the ruler to the fold and cut the angled sides. Unfold and cut the half-hexies apart. Repeat for all 13 squares.

Yield: 12 print roofs; 14 solid sky

Follow the diagram and stitch a solid half-hexie sky to a print roof, then sky, roof and so on. You will need 6 half-hexie print roofs and 7 solid skies to make a row. Begin and end with a sky half-hexie. All roofs should be facing the same direction—the solid sky half-hexies the opposite direction. Make 2 roof/sky strips.

Match the roof strip to the houses making sure each house has a roof. The solid sky half-hexies on either end will be sticking out past the ends of the house row. Stitch one roof row to one house row. Press seams toward the houses. Use your rotary

cutter to trim off the excess half-hexie. Make 2 rows of houses.

5 a neighborhood

Cut the last 5″ strip of background fabric to the length of the house and roof rows. This center sky separates the two streets.

Sew a street to each side of the sky strip, roofs facing each other. Press toward the center. **Table runner center:** 18″x 43¾″

6 quilt & bind

Layer the tablerunner on batting and backing. Quilt the way you like. Square up all raw edges.

Cut (3) 2½″ strips, piecing end-to-end with diagonal seams. Fold in half lengthwise and press. Attach to your tablerunner, raw edges together with a quarter inch seam allowance. Turn the folded binding edge to the back and tack in place with an invisible stitch or machine stitch if you like. **Table runner size:** 18½″ x 44¼″

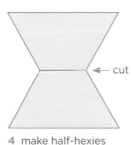
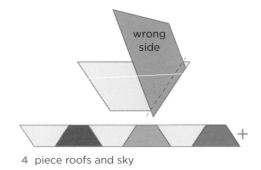

4 make half-hexies

4 piece roofs and sky

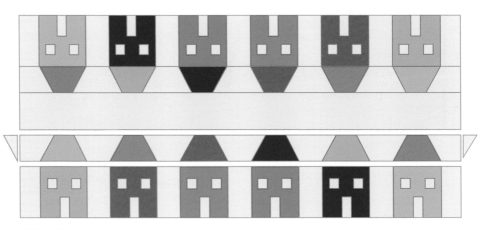

4 trim the roof ends
5 make a neighborhood

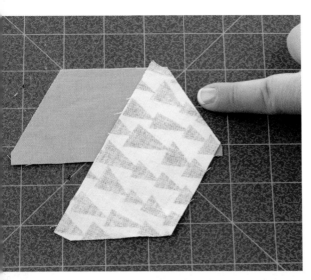

4 Sew angled sides to each other: narrow top meets wide bottom. Once pressed they will make a long strip. Let dog ears peek out!

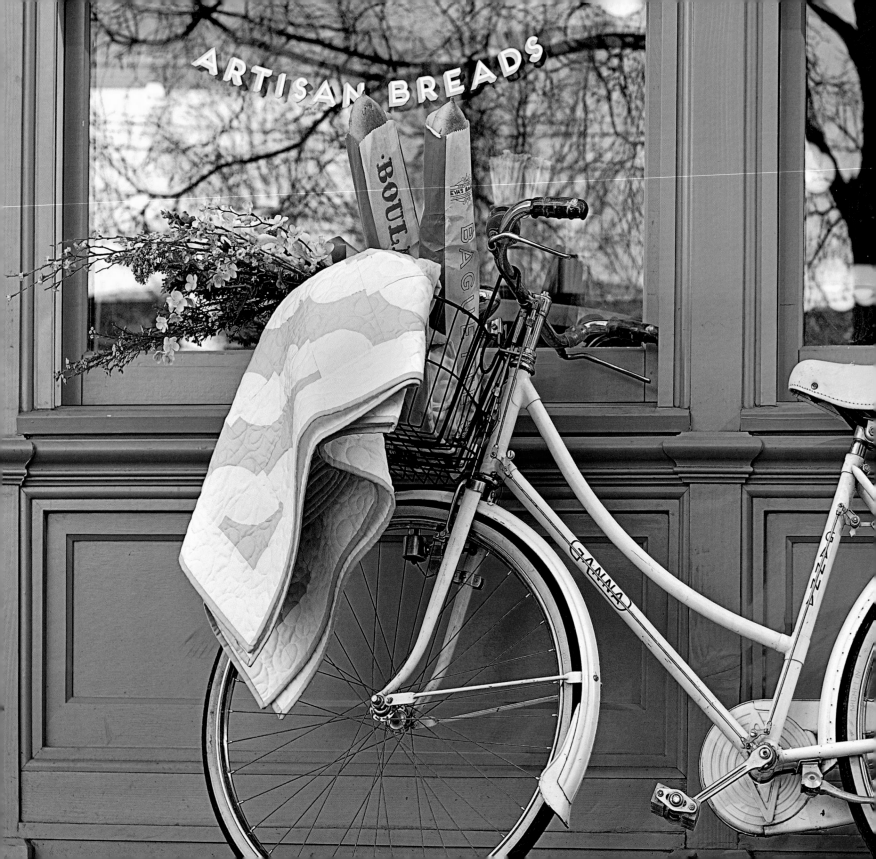

Real quilters have *curves*

quilt designed by JENNY DOAN

In today's world, if you're a good person you're called a "straight arrow," if you tell the truth you're a "straight shooter," if you're right about something you've "got the facts straight," if you fix something that's wrong you "set things straight," and if you're righteous you're "on the straight and narrow." What I want to know is, what's so wrong with curves?

Curves are the natural order of things. How many things in nature are straight, really? Relatively few. Instead, God graced this earth with gentle riverbends, ringed tree-trunks and the halo of the moon. Not to mention the soft circle of a gramma's hugging arms!

But I have to be honest, when it comes to quilting, I am usually most comfortable with straight lines. They're just easier to measure, cut, sew, and iron. (And you know me,

79

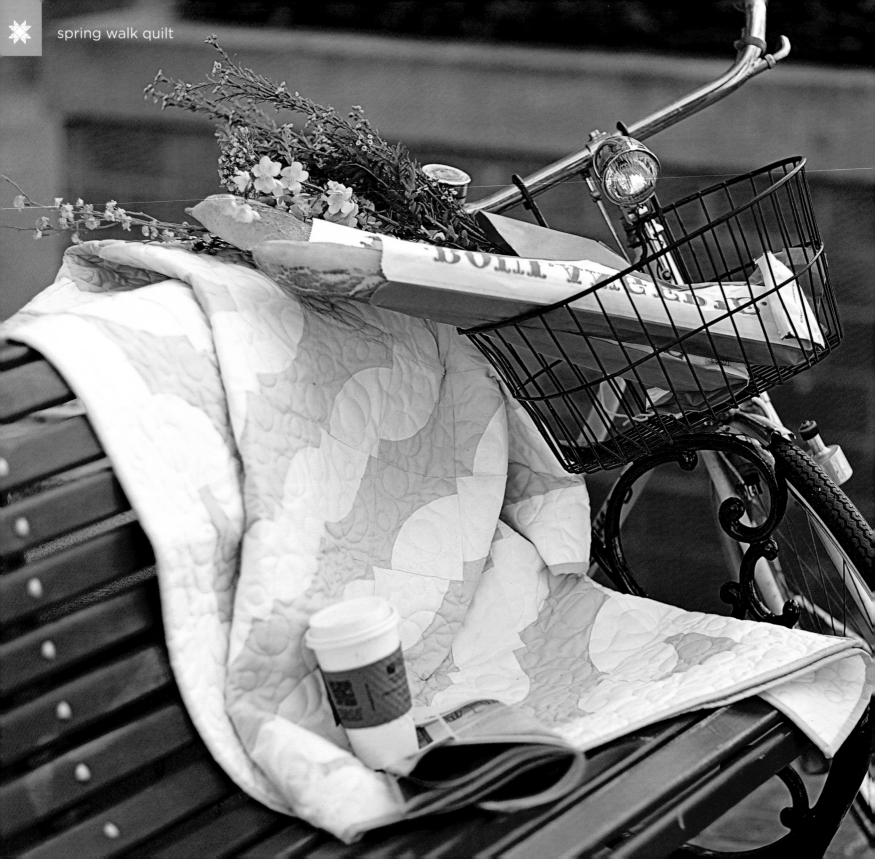

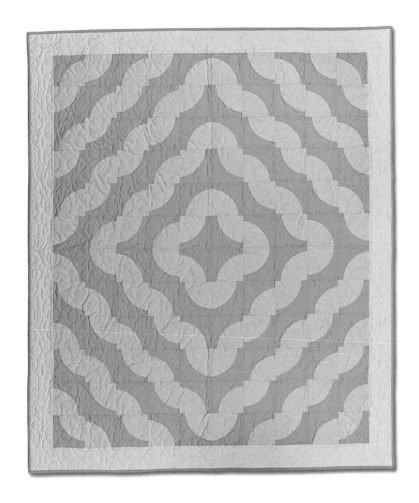

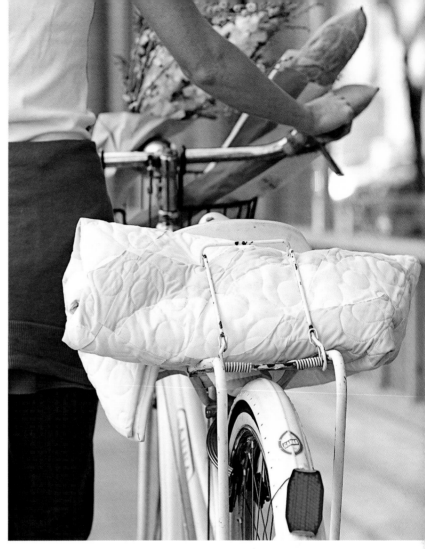

I'm a big fan of easy!) I love the idea of curved piecing, but it never seems to come out quite right. Then, one day it hit me (like a big square anvil): what if I were to appliqué a circle onto a square and cut it into fourths? Well hallelujah! The easiest Drunkard's Path on the planet. Then I could just rearrange the curves to my heart's content.

The thing I love about this quilt is how the curves make such organic shapes. When we made one in blue and white it reminded me so much of the ocean; it's got such great movement and flowing lines. I grew up next to the ocean and that's probably the thing I miss the most living out here in the Midwest. So for me, this pattern sent me right back to the water's edge and the serenity and beauty of the sea. I love that a quilt can do that! I mean, the ocean is only a plane ride away, but now with this quilt it's just in the next room.

I'm not afraid of quilting curves anymore, and I love the looks I can get with this method. If you avoid piecing curves, head STRAIGHT to your sewing machine and give this quilt a try!

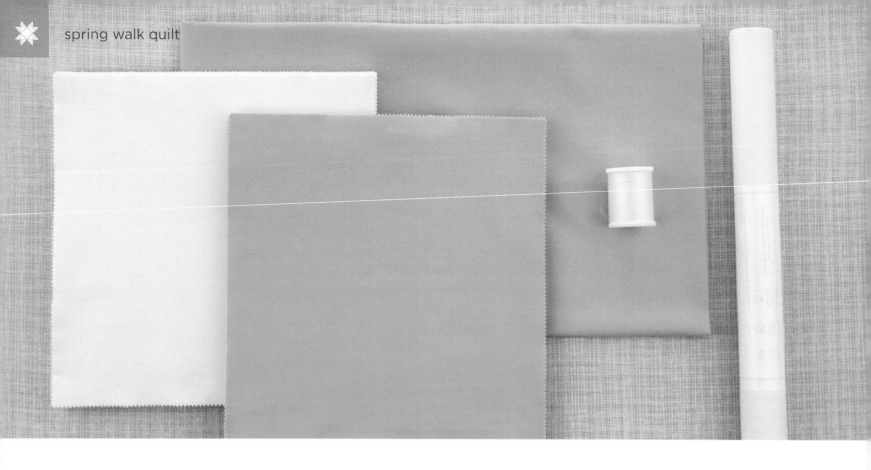

materials

makes a 52" X 61" layer cake quilt

QUILT TOP
- 1 layer cake white
- 1 layer cake aqua
- ⅝ yd outer border

BINDING
- ½ yd coordinating fabric

BACKING
- 3¼ yds 45" wide **OR** 1⅝ yds 90" wide

EXTRAS
- Heat 'N Bond
- Easy Circle Cut Ruler
- 18 mm rotary cutter
- rotating **OR** small cutting mat

SAMPLE QUILT
- **Bella Solids Robin's Egg Blue** (85) by Moda Fabrics
- **Bella Solids White** (98) by Moda Fabrics

1 heat 'n bond

Cut (30) 9½" squares of *Heat 'N Bond*. Adhere a 9½" Heat 'N Bond square to the back of a white layer cake. The bumpy side faces the wrong side of the fabric. Using an adhesive square that is slightly smaller than the layer cake will better protect the ironing board from mishaps. Press into place with dry heat. Make 30

2 cut circles

Fold a white layer cake in half, Heat 'N Bond to the inside. Line up the *Easy Circle Cut Ruler* to the *Fabric Fold Line* and cut using the 8" finished half circle groove with your 18mm rotary cutter. This makes an 8½" circle.

white layer cake represented in gray

1 iron bumpy side of adhesive to fabric back

fold

2 fold layer cake in half to cut circle

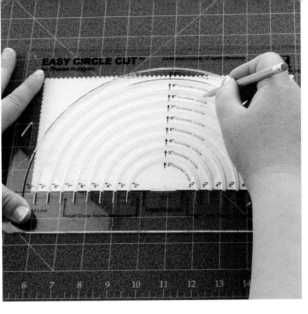

1 Press the *Heat 'n Bond* to the back of a white layer cake.

2 The Easy Cut Circle Ruler is used on a folded layer cake.

3 Stitch the white circle onto the blue layer cake. Here we are using a blanket stitch.

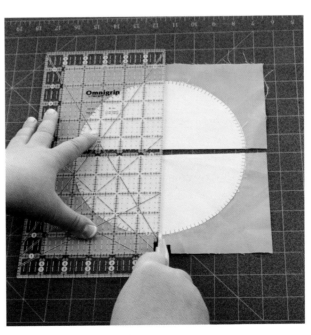

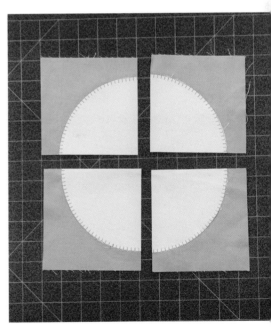

4 Cut the block in half at 5."

5 Turn the block and cut in half again at 5." Keep the block together. (This is split to show the block has been cut once.)

6 You will end up with (4) 5" squares.

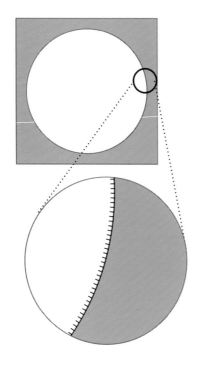

3 construct block

Remove the paper backing from the adhesive. Place the 8½" white circle in the middle of a 10" solid layer cake judging by eye to center it. Press to attach. Stitch around the circle's raw edge with a zig-zag, straight or blanket stitch. Make 30

4 cut

For this step use a rotating cutting mat, or a small mat that can be picked up to turn the entire block without disturbing the fabric. Cut the block in half, turn, and in half again. You now have (4) 5" squares. Repeat.
Yield: 120 blocks

5 arrange & sew

This version of Drunkard's Path is built using 2 rows: **A** & **B**. The easiest way to arrange a row is to start with the center blocks and add blocks on either side from there. The blocks are laid out in a 10 x 12 grid. Sew blocks together by row, left to right. Press all seams in one direction for A rows; opposite direction for B rows. This will help to nest seams when rows are sewn together. Make (6) **A** rows and (6) **B** rows.

Construct the quilt center. Sew 6 quilt rows together following this sequence: **A-B-A-B-A-B**. Make 2. Nest the seams as you sew. Turn one half upside down and sew the bottom half to the top half.
Quilt Center: 45½" x 54½"

6 outer border

Cut (5) 3½" strips of border fabric. Measure quilt width and cut 2 border strips to that size. Piece strips together end-to-end if need be. Attach one to the top; the other to the bottom. **1 & 2** Do the same for both sides measuring the length. Include the newly attached borders in the measurements. **3 & 4**

7 quilt & bind

Layer quilt top on batting and backing and quilt the way you like. Square up all raw edges. Cut (6) 2½" strips and piece together diagonally, aka the plus sign method.

Fold in half lengthwise, press. Attach to your quilt raw edges together with a quarter inch seam allowance. Turn the folded binding edge to the back and tack in place with an invisible stitch or machine stitch if you like.

Row A

Row B

Stained Glass quilt

quilt designed by JENNY DOAN

A friend of mine decided to try her hand at quilting when she
was pregnant with her first baby. She selected a beautiful gender-
neutral palette of soft yellows and set to work. But it wasn't long
before morning sickness hit hard, and her baby quilt progressed
more slowly as a result. She finally finished just before her sweet
little boy was born. To her surprise, the first time she pulled out
the quilt to wrap it around her new little bundle of joy, a wave of
nausea washed over her. To this day the very sight of that quilt
makes her stomach turn. Rather than reminding her of her now-
grown babe, this little baby quilt carries with it less welcome
memories of nine months of queasiness!

Every quilt tells a story. There is always something, an experience,
an inspiration, a loved one that makes that quilt unique and special.
For me, the Stained Glass Table Runner reminds me of my father.

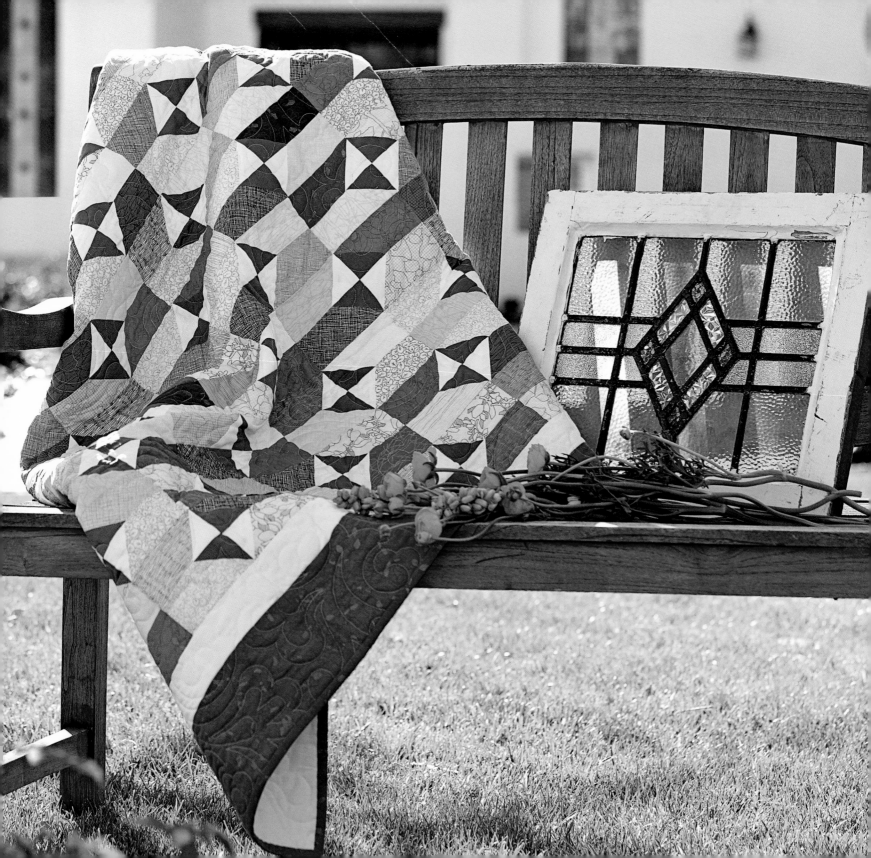

My father was a chemist and he spent much of his life working in a lab, but he also loved to work with his hands. It was such an enjoyable hobby for him that he actually restored our entire Victorian house with his own hands. From the wood-work to the brickwork, he did it all! I have always been quite the "daddy's girl" and I just loved to spend time with him, watching him work. It didn't matter where he was or what he was doing, I just wanted to be with him.

When he learned the art of stained glass, he quickly fell in love with it. I loved to watch his hands as they touched the colorful pieces of glass and skillfully arranged them into wondrous works of art. The first time I made a quilt with the Stained Glass pattern, I used solid fabrics to recreate the look of Dad's stained glass windows. I love that every time I look at my Stained Glass quilt, I immediately think of my father. For me, this quilt is a representation of his talents and his love for all things beautiful.

We all have gifts to share. From stained glass to quilts, each of us has the ability to brighten and beautify our own little corner of the world using our unique skills and imaginations. I may not be able to make a stained glass window, but with this pattern I can add a beautiful touch to my home.

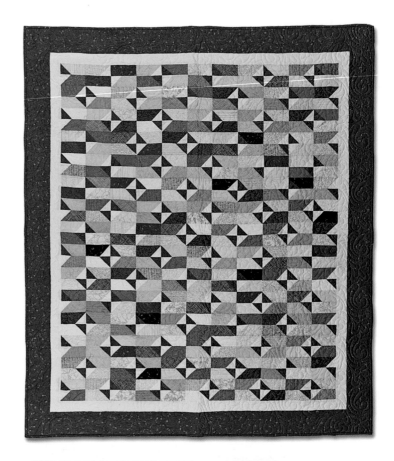

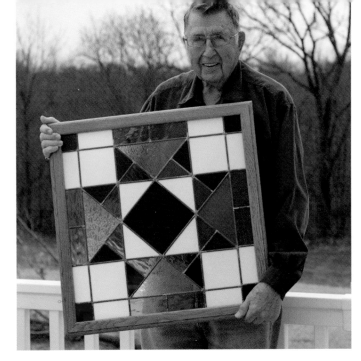

MY DAD, FRANK FISH shows us his Missouri Star window that he made for MSQC when we had just started our little company.

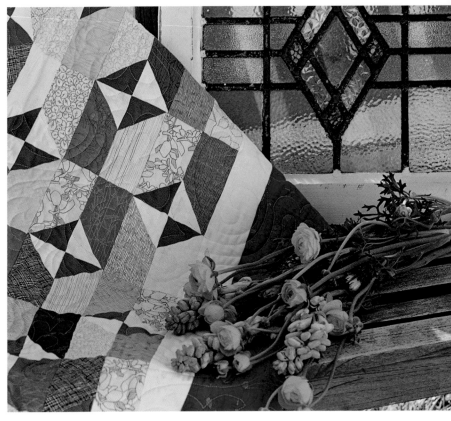

" "...each of us has the ability to brighten and beautify our own little corner of the world... "

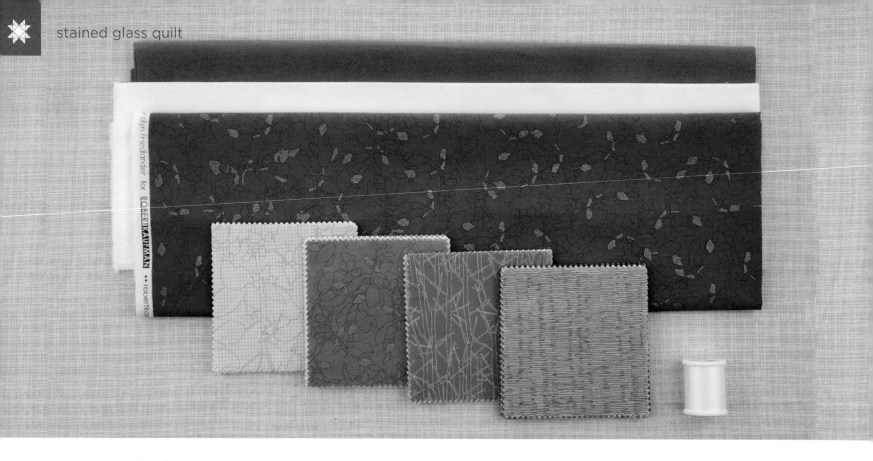

materials

makes a 63½" x 74" charm pack quilt

QUILT TOP
- 4 charm packs
- 1¼ yd solid white & inner border
- ¾ yd solid gray
- 1 yd outer border

BINDING
- ½ yd coordinating fabric

BACKING
- 4 yds 44" wide fabric OR 2 yds 90" wide fabric

SAMPLE QUILT
- **Botanics** by Carolyn Friedlander for Robert Kaufman Fabrics
- **Bella Solids White** (98) by Moda Fabrics
- **Bella Solids Gray** (83) by Moda Fabrics

1 cut

Cut all but 3 charm squares in half once to make 2½" x 5" rectangles. Divide into 2 equal stacks. There should be a good mix of lights and darks in each stack.
Yield: 2 stacks 165 rectangles

From the white fabric cut (10) 2½" strips; subcut into (165) 2½" squares: about 17 per strip. Repeat for gray fabric.
Yield: (165) 2½" white squares
 (165) 2½" gray squares

2 dog ear

Dog ear each rectangle. Iron a diagonal fold into each of the gray and white 2½" squares. This will be the sewing line.

Begin with white squares and 1 stack of rectangles. Lay the 2½" square RST on a rectangle. Chain piece all white squares onto 1 stack rectangles one after the other in the same direction. Snip threads between blocks. Trim excess fabric from behind the dog ear leaving a ¼" seam allowance. Press toward the rectangle. Repeat for the gray squares and the second stack of rectangles. Make sure the angle is opposite of the white squares.

2 iron diagonal fold line into all gray & white squares

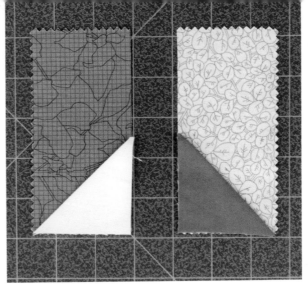
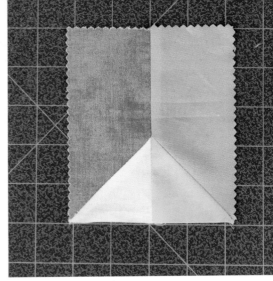

1 Cut each charm square in half.

2 Pair two dog-eared rectangles: 1 with a grey dog ear, the other with a white dog ear.

3 The dog ears form a "V" shape.

2 gray and white squares are angled in different directions. Pair rectangles that are light & dark.

3 make sure the gray & white triangles create a "V" shape

Chain piece, snip apart, and trim. This time press toward the gray square.

3 construct block

Pair one white and one gray dog-eared rectangle. Try matching up light and dark rectangles. Sew them right sides together (RST) so the two triangles make a V shape. Nest the V seams as you sew. Press to the gray square.
Block size: 4½" x 5"

4 arrange & sew

The quilt is layed out into an 11 x 15 grid. Orient the V blocks in an alternating direction: down, up, down, up, and so on.

Begin the next row with the V orientation reversed. Follow the diagram. Here's where a design wall comes in handy. But a floor or large table does the trick too.

Sew blocks together across to make a row; then in rows to make the center. Press seams to the same side in each even row; to the opposite side in each odd row. By doing so, nesting seams will be a snap. Sew rows together.
Quilt center: 50" x 60½"

5 borders

Cut (7) 2½" strips of white fabric for the inner border. Measure widthwise in 3 places. Cut 2 strips to the average measurement, piecing strips when needed. Stitch 1 strip to the top; 1 to the bottom. **A** & **B** Press to the borders.

Repeat for the side borders, except measure 3 times lengthwise. Include the newly attached borders in your measurements. Cut 2 strips to the average length, piecing strips together when needed. Attach 1 to each side. **C** & **D** Press to the borders.

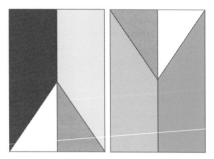

4 Alternate the orientation of the V.

For the outer border cut (7) 5″ strips. Attach in the same manner as the inner border.

6 quilt & bind

Layer quilt top on batting and backing and quilt the way you like. Square up all raw edges.

Cut (7) 2½″ strips of binding. Piece together end-to-end with diagonal seams, aka the plus sign method. Fold in half lengthwise, press. Attach to the quilt raw edges together with a ¼″ seam allowance.

Turn the folded binding edge to the back and tack in place with an invisible stitch or machine stitch if you like.

Quilt size approx: 63½″ x 74″

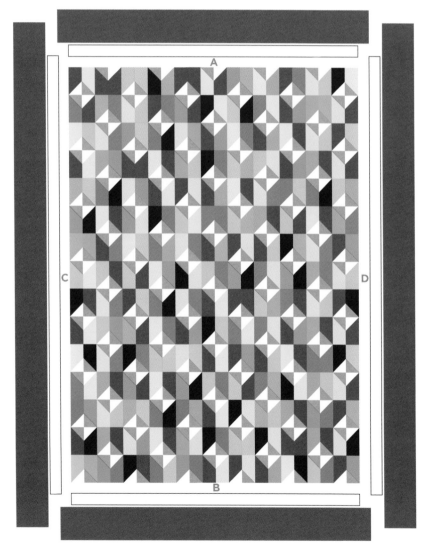

5 add borders

How to square up your quilt blocks

Squaring up quilt blocks is a step that I often skip altogether. If your quilt is made using precuts and your seams are fairly consistent, your blocks should all be about the same size. If they are within a ¼" of each other, squaring isn't necessary because you will be able to make them fit by pinning and easing. Any blocks that are off by more than a ¼" will need to be squared up.

You will want to measure all of your blocks and square to the smallest size. Its possible to cut them down, but making them larger is much more difficult! ha!

If you're working with half square triangles, or your block has a 45 degree angle, use that seam to keep your points and make your block square. Take your square ruler and line up the 45 degree angle on the diagonal seam on your block. Depending on your block you may need to square up all four sides or just two of them!

If you are squaring up a block that doesn't have a diagonal line you will want to measure the block pieces and try to keep them consistent. I usually try to keep all the finished sizes the same and measure from the center out. So if you are squaring a nine patch, measure the center block. If it measures 2" square, you will want your outer edge squares to measure 2" x 2½" so that when you join these blocks to the rest of your quilt, your finished nine patch will have 9"-2" finished blocks in it. If this is not possible, just do your best and eyeball it. A square block is going to make a square quilt, and most of these little differences in size will not show in the finished quilt.

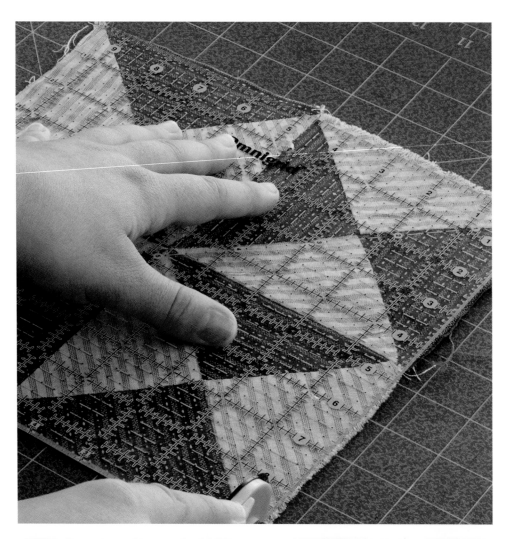

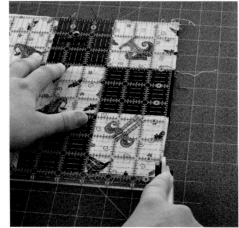

Make a fabric covered button

We use a great button cover kit by Maxant. They come in several different sizes and are very easy to use!

INCLUDED IN EACH PACKAGE IS:

- **Rubber Holder** - these are usually white or clear and are pretty flexible.
- **Plastic Pusher** - these are bright blue hard plastic.
- **Metal Button Top Shell And Back** - the top is a smooth curved piece of metal, the back is a flat piece of metal with a hook attached.

All you need to make a button is a small scrap of fabric about 2½"-3" square to make the largest size.

The size is listed on the front of the package. On the back of each package is a circle template with different numbers on it.

STEP 1 - Cut out the cardboard template to the size you need.
STEP 2 - Using the cardboard template, cut your fabric to the right size circle.
STEP 3 - Center the fabric right side down over the plastic holder. Place the button top shell in the center of the fabric and press down.
STEP 4 - Place the button back onto the fabric in the center of the button top with the flat side toward the fabric. Using the pusher, press the button back into the button front and snap into place.
STEP 5 - Pop out your newly made button! They are so cute! These make adorable accents to purses, pillows, hair accessories, and many other craft or sewing projects.

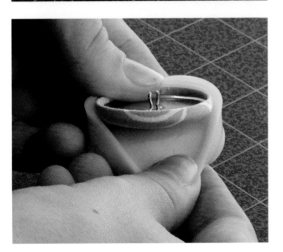

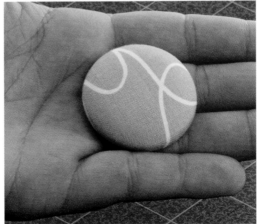

95

bowtie party

DESIGNED BY
Jenny Doan

PIECED BY
Stephen & Cassie Nixdorf

QUILTED BY
Kathleen Miller

QUILT SIZE
77" X 93"

QUILT TOP
8 charm packs
1 jelly roll background solid
½ yd background solid
1¼ yds outer border

BINDING
⅔ yd coordinating fabric

BACKING
5½ yds 44" wide fabric
OR 2⅓ yds 108" wide backing

SAMPLE QUILT
True Colors by Anna Maria
Horner for Free Spirit Fabrics

Bella Solids Snow (11)
by Moda Fabrics

ONLINE TUTORIALS
msqc.co/bowtie

QUILTING
Flower Swirls

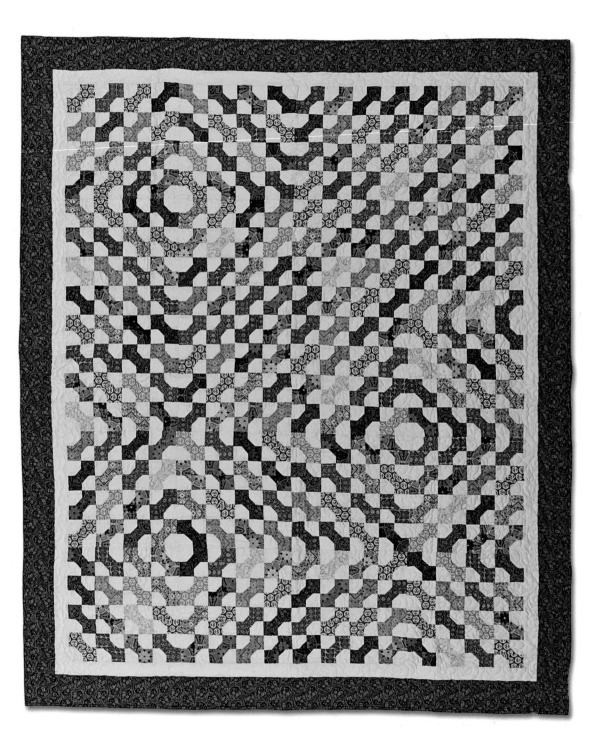

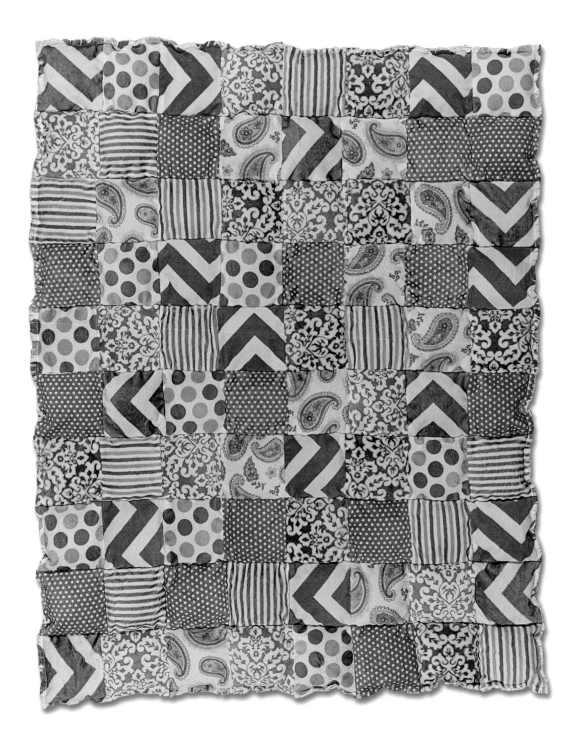

cloud
nine

DESIGNED BY
Natalie Earnheart

PIECED BY
Natalie Earnheart

QUILT SIZE
35" X 43"

QUILT TOP
8 charm packs

EXTRAS
Rag Quilt Snips by Fiskars
polyester stuffing

SAMPLE QUILT
Girly Girl Cuddle Cloth
by Shannon Fabrics

ONLINE TUTORIALS
msqc.co/cloudnine

dresden coins

DESIGNED BY
Natalie Earnheart

PIECED BY
Natalie Earnheart

QUILTED BY
Emma Jensen

QUILT SIZE
76" X 80"

QUILT TOP
2 layer cakes
1¼ yds solid for sashing &
1st inner border
½ yd 2nd inner border
1¼ yds outer border

BINDING
⅝ yd coordinating fabric

BACKING
5 yds 44" wide fabric
OR 2¼ yds 90" wide fabric

TOOLS
MSQC 10" Dresden Plate Ruler

SAMPLE QUILT
Pastel Pops Citron
by Michael Miller Fabrics

Bella Solids White (98)
by Moda Fabrics

ONLINE TUTORIALS
msqc.co/dresden

QUILTING
Square Meandering

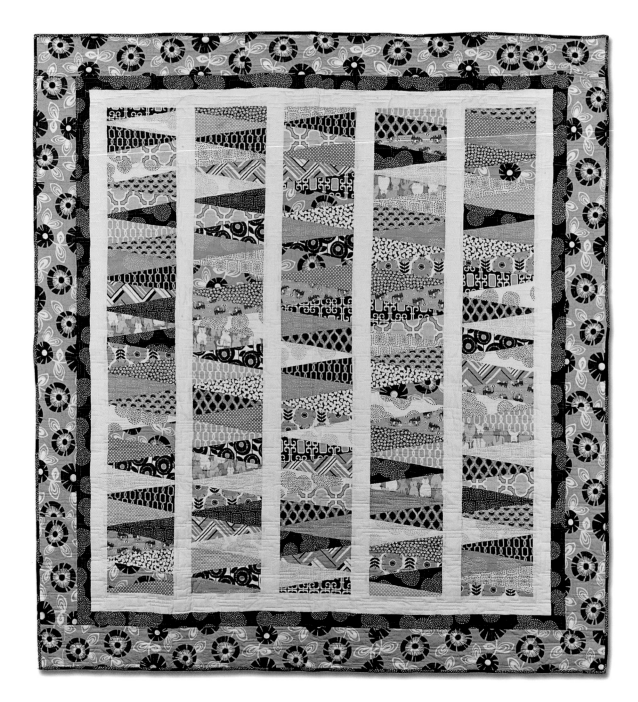

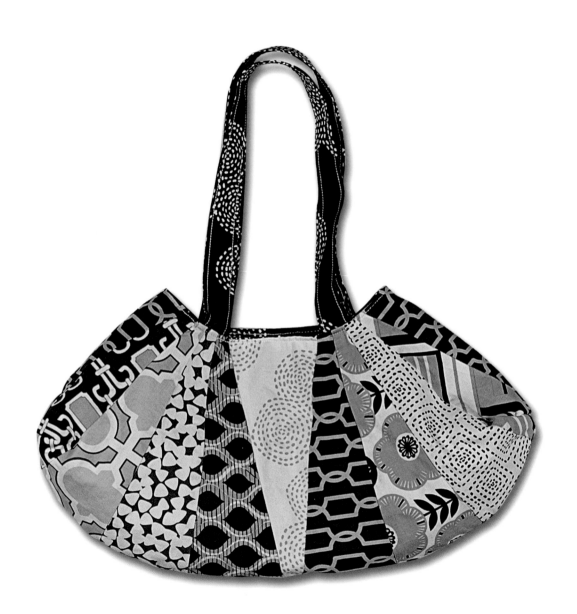

DESIGNED BY
Stephen Nixdorf

PIECED BY
Stephen Nixdorf

BAG
1 layer cake
¾ yd lining & handles

INTERFACING
2 yds Pellon shape flex 101
fusible woven interfacing

TOOLS
MSQC 10" Dresden Plate Ruler

SAMPLE BAG
Pastel Pops Citron Grey
by Michael Miller Fabrics

ONLINE TUTORIALS
msqc.co/sparechange

dresden
all in a row
and
all in a roll

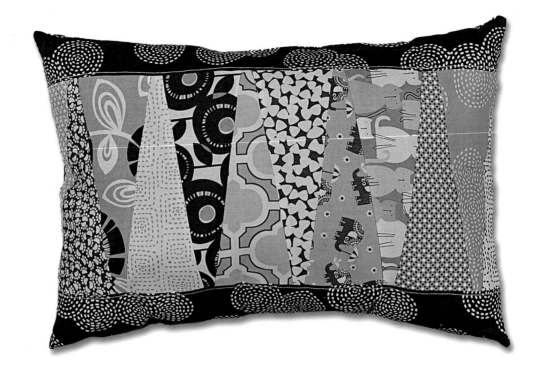

DESIGNED BY
Jenny Doan & Stephen Nixdorf

PIECED BY
Stephen Nixdorf

ALL IN A ROW PILLOW
11 leftover Dresden Plate
wedges from Dresden Coin
Quilt project
½ yd backing

ALL IN A ROLL PILLOW
20 leftover Dresden Plate
wedges from Dresden Coin
Quilt project
¾ yd backing

TOOLS/EXTRAS
MSQC 10″ Dresden Plate Ruler
polyester stuffing
1 large coordinating button
Heat 'N Bond

SAMPLE PILLOW
Pastel Pops Citron Grey
by Michael Miller Fabrics

ONLINE TUTORIALS
msqc.co/allinarow

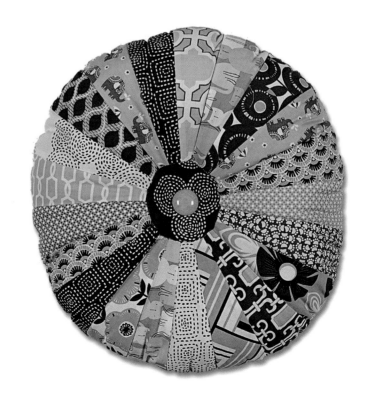

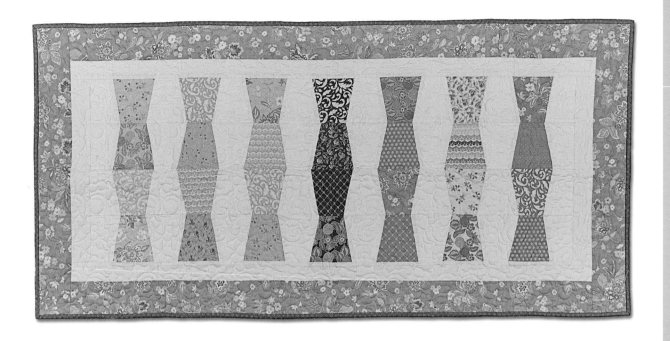

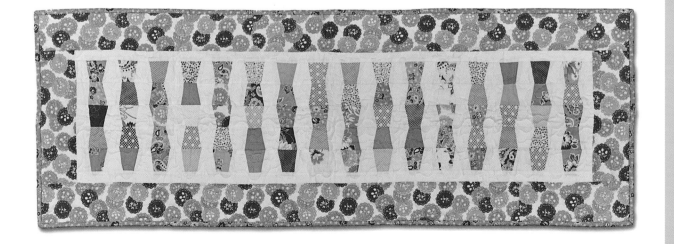

DESIGNED BY
Jenny Doan

PIECED BY
Jenny Doan

QUILTED BY
Cassie Martin

CHARM TABLE RUNNER SIZE
30" X 60½"

CHARM TABLE RUNNER
1 charm pack
1 yd inner border & bkgnd solid
½ yd outer border
⅜ yd binding
1⅛ yds backing

MINI CHARM RUNNER SIZE
17½" X 57½"

MINI CHARM RUNNER
2 mini charm packs
¾ yd inner border & bkgnd solid
⅜ yd outer border
⅓ yd binding
1¾ yd backing

TOOLS
MSQC Tumbler Charm Ruler
MSQC Mini Tumbler Charm Ruler

SAMPLE CHARM RUNNER FABRIC
Mirabelle by Fig Tree & Co.
for Moda Fabrics
Bella Solids Bleached White PFD
(97)by Moda Fabrics

SAMPLE MINI CHARM RUNNER FABRIC
Scrumptious by Bonnie & Camille
for Moda Fabrics
Bella Solids Bleached White PFD
(97)by Moda Fabrics

ONLINE TUTORIALS
msqc.co/flowerfancy

QUILTING
Flower Swirls

magic diamonds

DESIGNED BY
Jenny Doan

PIECED BY
Jenny Doan

QUILTED BY
Kathleen Miller

QUILT SIZE
59" X 79"

QUILT TOP
3 charm packs print
3 charm packs solid
½ yd inner border solid
1½ yds outer border

BINDING
½ yd coordinating fabric

BACKING
3¾ yds 45" wide fabric
OR 2 yds 90" wide fabric

TOOLS
rotating cutting mat **OR**
small cutting mat

SAMPLE QUILT
Chance of Flowers by Sandy
Gervais for Moda Fabrics

Bella Solids Snow (11)
by Moda Fabrics

ONLINE TUTORIALS
msqc.co/magicdiamonds

QUILTING
Posies

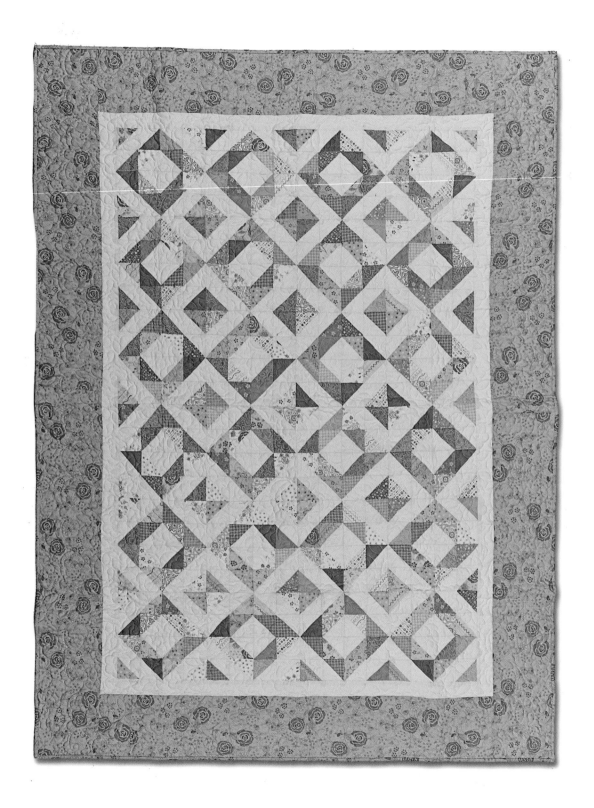

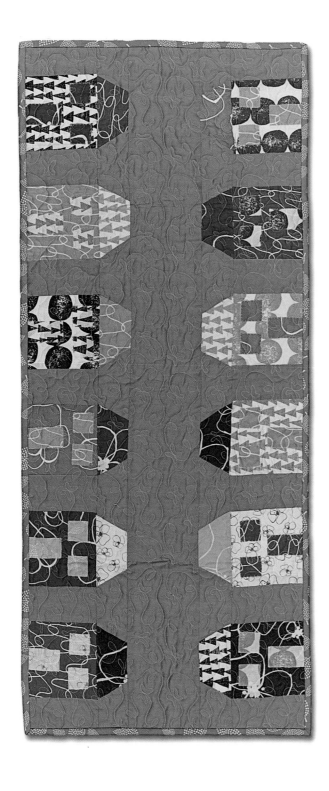

DESIGNED BY
Jenny Doan

PIECED BY
Jenny Doan

QUILTED BY
Daniela Kirk

TABLE RUNNER SIZE
18½" X 44¼"

TABLE RUNNER
1 charm pack print
½ yd background solid

BINDING
⅓ yd coordinating fabric

BACKING
1⅜ yd coordinating fabric

EXTRAS
Heat 'N Bond
5" Half Hexagon Ruler

SAMPLE QUILT
Mor Mor by Lotta Jansdotter
for Windham Fabrics

ONLINE TUTORIALS
msqc.co/minihouse

QUILTING
Flutterby

spring walk

DESIGNED BY
Jenny Doan

PIECED BY
Jenny Doan

QUILTED BY
Jamey Stone

QUILT SIZE
52" X 61"

QUILT TOP
1 layer cake white
1 layer cake aqua
⅝ yd outer border

BINDING
½ yd coordinating fabric

BACKING
3¼ yds 45" wide **OR**
1⅝ yds 90" wide

EXTRAS
Heat 'N Bond
Easy Circle Cut Ruler
18 mm rotary cutter
rotating cutting mat **OR**
small cutting mat

SAMPLE QUILT
Bella Solids Robin's Egg Blue
(85) by Moda Fabrics
Bella Solids White (98)
by Moda Fabrics

ONLINE TUTORIALS
msqc.co/springwalk

QUILT PATTERN
Champagne Bub

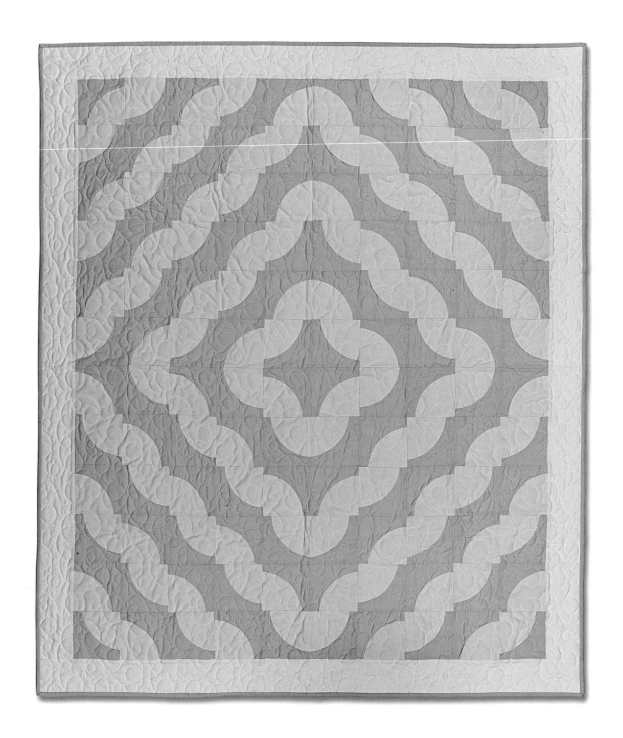

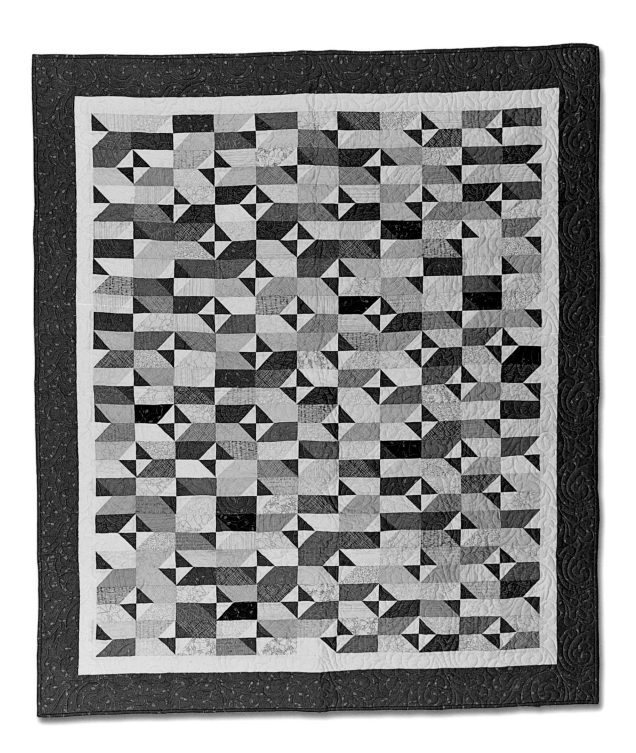

stained glass

DESIGNED BY
Jenny Doan

PIECED BY
Natalie Earnheart

QUILTED BY
Sherry Melton

QUILT SIZE
63½" x 74"

QUILT TOP
4 charm packs
1¼ yd solid white & inner border
¾ yd solid gray
1 yd outer border

BINDING
½ yd coordinating fabric

BACKING
4 yds 44" wide fabric
OR 2 yds 90" wide fabric

SAMPLE QUILT
Botanics by Carolyn Friedlander
for Robert Kaufman Fabrics

Bella Solids White (98)
by Moda Fabrics

Bella Solids Gray (83)
by Moda Fabrics

ONLINE TUTORIALS
msqc.co/stainedglass

QUILTING
Variety

sweet annie

DESIGNED BY
Jenny Doan

PIECED BY
Jenny Doan

QUILTED BY
Amy Gertz

QUILT SIZE
42½" X 49¼"

QUILT TOP
1 layer cake
¾ yd bkgrnd & inner border
½ yd outer border

BINDING
⅜ yd coordinating fabric

BACKING
1½ yds 44/45" wide

SAMPLE QUILT
Spring Showers by Another Point of View for Windham Fabrics

Bella Solids White (98) by Moda Fabrics

ONLINE TUTORIALS
msqc.co/sweetannie

QUILTING
Umbrellas

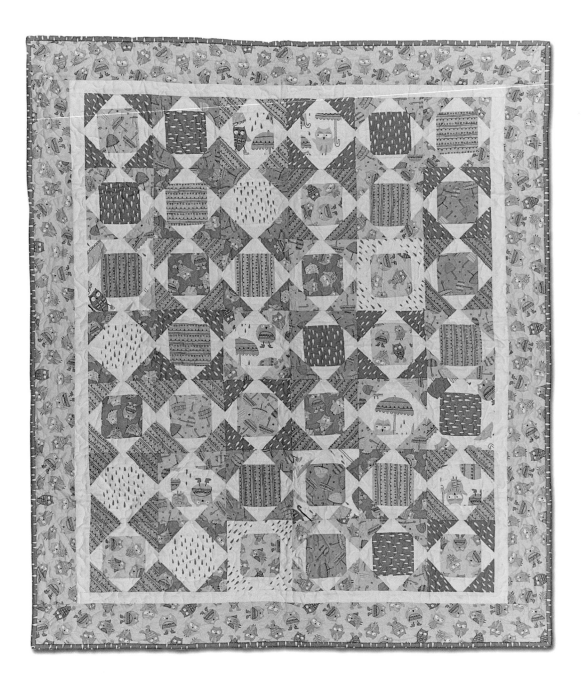

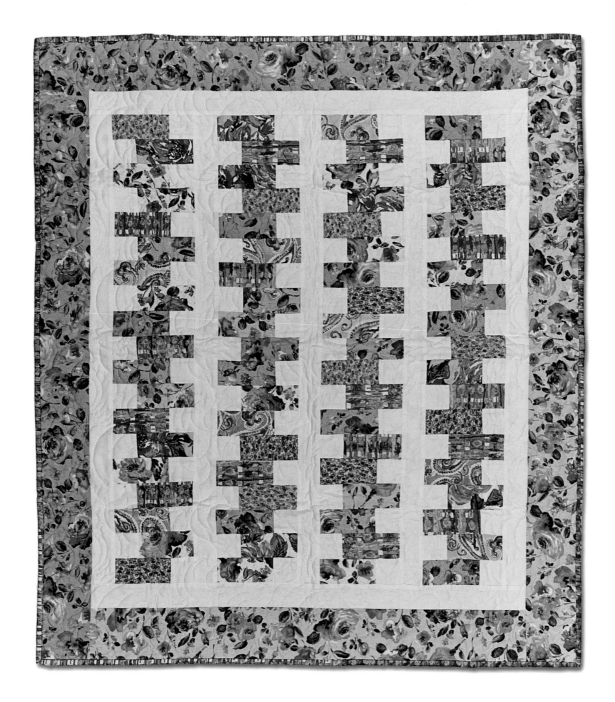

zip it

DESIGNED BY
Jenny Doan

PIECED BY
Cassie Nixdorf

QUILTED BY
Amber Weeks

QUILT SIZE
45" X 51"

QUILT TOP
1 charm pack
1 yd solid for sashing,
cornerstones, & inner border
¾ yd outer border

BINDING
½ yd coordinating fabric

BACKING
3⅛ yds coordinating fabric

SAMPLE QUILT
Ambrosia by Jennifer Young
for Benartex
Bella Solids White (98)
by Moda Fabrics

ONLINE TUTORIALS
msqc.co/zipit

QUILTING
Kathy's Roses

general guidelines

- All seams are ¼" inch unless directions specify differently.

- Cutting instructions are given at the point when cutting is required.

- Precuts are not prewashed; therefore do not prewash other fabrics in the project

- All strips are cut WOF

- Remove all selvedges

- All yardages based on 40" WOF

ACRONYMS USED

MSQC	Missouri Star Quilt Co.
RST	right sides together
WST	wrong sides together
HST	half square triangle
WOF	width of fabric
LOF	length of fabric

pre-cut glossary

CHARM PACK

1 = (42) 5" squares or ¾ yd of fabric
1 = baby
2 = crib
3 = lap
4 = twin

JELLY ROLL

1 = (42) 2½" strips cut the width of fabric or 2¾ yds of fabric
1 = a twin
2 = queen

LAYER CAKE

1 = (42) 10" squares of fabric: 2¾ yds total
1 = a twin
2 = queen

The terms charm pack, jelly roll, and layer cake are trademarked names that belong to Moda. Other companies use different terminology, but the sizes remain the same.

When we mention a precut, we are basing the pattern on a 40-42 count pack. Not all precuts have the same count, so be sure to check the count on your precut to make sure you have enough pieces to complete your project.

press seams

- Use a steam iron on the cotton setting.

- Iron the seam just as it was sewn RST. This "sets" the seam.

- With dark fabric on top, lift the dark fabric and press back.

- The seam allowance is pressed to the dark side. Some patterns may direct otherwise for certain situations.

- Follow pressing arrows in the diagrams when indicated.

- Press toward borders. Pieced borders may demand otherwise.

- Press diagonal seams open on binding to reduce bulk.

binding

- Use 2½" strips for binding.

- Sew strips end-to-end into one long strip with diagonal seams, aka plus sign method (next). Press seams open.

- Fold in half lengthwise WST and press.

- The entire length should equal the outside dimension of the quilt plus 15" - 20."

plus sign method

Diagonal seams are used when straight seams would add too much bulk.

- Lay one strip across the other as if to make a plus sign RST.

- Sew from top inside to bottom outside corners crossing the intersections of fabric as you sew. Trim excess to ¼" seam allowance.

- Press seam open.

wrong side

attach binding

- Match raw edges of folded binding to the quilt top edge.

- Leave a 10" tail at the beginning.

- Use a ¼" seam allowance.

- Start in the middle of a long straight side.

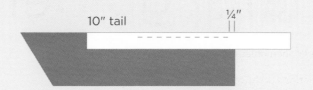

miter binding corners

- Stop sewing ¼" before the corner.

- Move the quilt out from under the pressure foot.

- Clip the threads.

- Flip the binding up at a 90° angle to the edge just sewn.

- Fold the binding down along the next side to be sewn.

- Align the fold to the edge of the quilt that was *just sewn*;

- Align raw edges to the side *to be sewn*.

- Begin sewing on the fold.

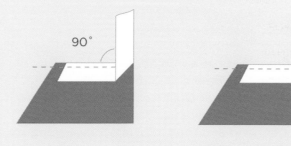

close binding

MSQC recommends **The Binding Tool** *from TQM Products to finish binding perfectly every time.*

- Stop sewing when you have 12" left to reach the start.

- Where the binding tails come together trim excess leaving only 2½" of overlap.

- It helps to pin or clip the quilt together at the two points where the binding starts and stops. This takes the pressure off of the binding tails while you work.

- Use the plus sign method to sew the two binding ends to-gether, except this time when making the plus sign, match the edges. Using a pencil mark your sewing line since you won't be able to see where the corners intersect. Sew across.

- Trim off excess; press seam open.

- Fold in half WST and align all raw edges to the quilt top.

- Sew this last binding section to the quilt. Press.

- Turn the folded edge of the binding around to the back of the quilt and tack into place with an invisible stitch or machine stitch if you wish.

borders

- Always measure the quilt center 3 times before cutting borders.

- Start with the width and measure the top edge, middle and bottom.

- Folding the quilt in half is a quick way to find the middle.

- Take the average of those 3 measurements.

- Cut 2 border strips to that size.

- Attach one to the top; one to the bottom of the quilt.

- Position the border fabric on top as you sew. The feed dogs can act like rufflers. Having the border on top will prevent waviness and keep the quilt straight.

- Repeat this process for the side borders, measuring the length 3 times.

- Include the newly attached top and bottom borders in your measurements.

- Press to the borders.

PATCHWORK MURDER

PART 1
Piecing It Together

A JENNY DOAN MYSTERY

written by Steve Westover

Jenny Doan tugged at her apron and smiled before concluding. "We hope you've enjoyed this tutorial on sashing from the Missouri Star Quilt Company." She maintained her smile, waiting for her cue.

Karen raised her hand and then it lowered, indicating the recording had stopped. Jenny exhaled a deep sigh and then made a production of wiping imaginary sweat from her brow. Her smile brightened the room as five customers who had been watching broke into a fit of applause.

"One of my favorites, Mom," Sean said but it was the same compliment he used after every tutorial.

Jenny raised one eyebrow to challenge Sean's praise but then bowed for the gathered customers. The applause dissipated. "What? Only good enough for ten seconds of clapping?" she asked, smiling again and waving cheerfully.

She tossed scraps of sashing and completed garden blocks into a bin. Removing her black apron with the hot pink MSQC lettering and logo she set it over her sewing machine.

Sean studied his watch. "I've got to get going." His eyebrows pumped. "Got a date."

Jenny waved him away with a smirk. "I'll make sure everything's locked up."

Sean hustled out the door but Karen stayed behind. She moved the camera and lighting equipment into a closet and then rearranged a stack of charm packs.

"Aunt Jenny," MK called as she entered the room. "We're running a little late. Are you ready?"

Jenny studied MK with some bewilderment while Karen grabbed a clipboard and exited the office. "Matilda, what are you doing here?"

MK's mouth tightened into a frown as she tugged at her ponytail. She tucked a runaway strand of curly auburn hair behind her ear. She inhaled slowly...deeply. "Aunt Jenny, you forgot."

With mock indignation Jenny said, "I did not." She thought for a moment. "Forget what, exactly?"

"Two things," MK said. "First, please call me MK. I don't know what mom was thinking when she named me Matilda. She must have been on some kind of a British kick but it's MK. Please." Jenny nodded. "And the other thing?"

MK smiled as she removed a smart phone from the back pocket of her jeans. She pushed a button. "Our flight. We're late," she said pointing at the time display.

Jenny bit down on her lower lip. "Flight. Right." She thought some more and then recognition flashed in her widening eyes. "The Portland Conference." MK nodded. "That's today?" MK nodded again. Jenny's eyes narrowed. "I need to pack."

"Already done. The car's ready. We should have left five minutes ago."

Jenny looked around the shop as employees began end of day cleanup and restocking. The final customers exited but the bustle amongst the employees continued. "Let's do it," she said cheerfully as she followed MK toward the front of the store. "Karen, would you be a doll and lock up?"

"Of course. Have a good trip," Karen said but without her usual good cheer.

Jenny stopped and turned toward Karen who busied herself stacking jelly rolls in pyramid formation. "Sweetie, are you doing okay?" Jenny asked.

"Busy day," Karen said. "Aren't they all?"

Karen frowned. "I got something today." She reached to the cabinet below the register and held up a crystal vase with a massive bouquet of roses.

"Oh." Jenny's cheeks rose with delight. "Beautiful." "Two dozen," Karen said with emphasis.

Jenny's mouth hung open and her eyes widened. "Two dozen? Well, well." She paused while she studied Karen's expression. "So why don't you look happy?" Karen whispered. "They're not from Stewart. He didn't know anything about the flowers. He wasn't very happy about it."

Jenny's right brow shot skyward. "I bet not." Jenny exaggerated a frown but then asked in her usual upbeat tone, "Was there a card? Even if it wasn't signed, maybe you could…" Karen shook her head. "Did you ask the flower shop?"

"Yes, but Shelly wouldn't tell me. She said something about customer privacy. I've never heard of flower shop/client confidentiality before."

MK cleared her throat. "We're going to miss our flight."

"Hmm…Flower shop confidentiality? Me neither," Jenny said with a chuckle, ignoring MK. "Would you like me to check. Maybe Shelly will tell me."

"Would you?"

"Finish up. I'll be right back." Jenny pushed through the front door of the shop with MK close on her heels. "Jenny, Sean's going to kill me. We can't miss that plane." "You're my assistant, right?" Jenny asked with a mischievous smirk.

MK's shoulders bounced with defeat as she quickened her pace to keep up with Jenny's long strides.

A spring breeze swirled the scent of fresh flowers along the Hamilton city sidewalk as Jenny and MK crossed in front of the Quilting Center retreat. Jenny waved to the patrons sitting at quilting stations and then hurried the three blocks to the flower shop.

"Hi, Shelly. Can you help me with something?" Jenny asked. "I just need some information. You made a delivery to the shop today. We really need to know who sent the flowers. There wasn't a card," she explained.

"I really don't think I should," Shelly said. "I agreed to keep it a secret. It sounded like fun. Is there a problem?"

"Only with Karen's boyfriend, who was not the sender. Karen is curious. A secret admirer is pretty mysterious…romantic."

Shelly nodded in agreement. "I want to help but…" "What is it?"

"I can't tell you but I know who can," Shelly said. She grinned. "Your son, Sean."

"Really? How's that?" Jenny asked.

"He and the other sender were here at the same time. They knew each other," Shelly said. "Sean will remember."

"There's no anonymity in this Hamiltonian metropolis?" Jenny said in good humor. "Thank you, Shelly."

With the phone to her ear, Jenny strolled to the quilt shop with the answer she had been looking for. "MK, I'll be just a minute. Can you start the car?"

MK hesitated but then complied like a new assistant should.

"Thanks, Sean. That's what I needed," Jenny said into her phone.

"Just don't tell her Karen how you found out," Sean said. "I don't want Roger finding out it came from me. Gotta go. Oh, and Mom, MK may not always show it but peel back that stern, nothing-but-business expression and MK's really excited about this trip."

"She'll be a great help. 'Personal assistant' just sounds so pretentious." Jenny shuddered and then grinned when she heard Sean laughing through the phone.

"MK's about as straight an arrow as there is. We need someone to keep you out of trouble," Sean said.

"I'll be on my best behavior," Jenny agreed, a smile returning to her face. "Love you. Bye." Jenny looked to the silver SUV with MK tapping her fingers on the wheel. Jenny held up one finger and then hurried back into the quilt shop.

The employees had all cleared out except for Karen. She looked expectantly at Jenny. "Well…did she tell you?" Karen asked barely able to contain her enthusiasm.

"Yes…and…no," Jenny said playfully. Karen's brow furrowed as she waited for Jenny to explain. "Yes, I know who sent the flowers. But 'no', Shelly didn't tell me. She winked. I know how to piece things together. Do you know a boy named Roger?" Jenny asked. Karen squealed and then hopped up and down with delight. Yep, you know him. "Maybe your boyfriend has reason to worry."

Karen ran to Jenny and wrapped her arms around her, squeezing tight. "Thank you. Thank you. Thank you. I love working here."

"Me too."

Karen bounded through the door into the spring evening with an extra bounce to her step.

Flipping off the lights, Jenny punched in the security code and then joined MK in the SUV. "Ah, to be a teenager again."

"What?" MK asked.

"Nothing, sweetie. But we'd better hurry. We have a

flight to catch."

MK smiled. "Hold on."

Southwest Flight 3504 landed at Portland International Airport ahead of schedule with a smooth touchdown. MK nudged Jenny awake and then checked her watch. She pulled out her phone and stared at the display until it changed automatically to Pacific Time. 9:57 PM. She synchronized her watch. "We're here."

Jenny rubbed her eyes and stretched as much as possible in the confining cattle car that passed for an airplane. Bustling passengers grabbed their bags from overhead bins before disembarking with weary enthusiasm. She and MK followed, nodding to the flight crew. "How far to the hotel?"

"Twenty minutes," MK said. "A shuttle will take us to The Harrington."

With a firm grip on their rolling carry-ons, Jenny and MK wheeled through the terminal searching for the shuttle. Then Jenny saw him. A handsome Asian man wore black slacks and a crimson windbreaker. "Pacific Patchwork" was scrawled in thick black marker with "The Harrington" etched into his sign with fine cerise calligraphy.

"Hello," Jenny said trying to sound more awake than she felt. "We're going to the Harrington."

"Excellent. I'm Bruno. Do you have any other bags?" "Bruno? Irish?" Jenny asked with a smirk.

Bruno's voice was flat. "No."

"This is it," MK said. "Traveling light reduces problems."

Bruno hefted each bag and carried them briskly toward the terminal exit. "You can wait in the van. We have one more passenger." He loaded the bags into the back of the van and opened the door for the Jenny and MK.

Inside Jenny noted a chatty woman sitting in the middle row beside a clone who must have been her teenaged daughter. A slender, balding man leaned against the glass in the back. Climbing onto the front bench seat Jenny made room for MK and tried to get comfortable. Barry Manilow music enticed her to shut her eyes for just a moment.

"This is it," Bruno said as the van pulled alongside the curb. "If you check in at the front desk I'll deliver the luggage to your rooms."

"We're here," MK said, nudging Jenny. Jenny blinked herself into consciousness. Opening the sliding door MK stepped out onto the curb and Jenny followed.

The other passengers oozed from the van and passed beneath a crimson and cream striped awning on their way inside. Jenny remained on the curb, her eyes climbing the towering building as a light drizzle dampened her hair. Elegant white stone decorated the hotel facade before giving way to red brick.

"Jenny, you're getting wet," MK said, motioning for her to take shelter beneath the awning. Jenny inhaled another deep breath of misty pacific air before joining MK.

While MK checked in Jenny basked in the rich textures of mahogany and marble set in the ambiance of the lobby's soft yellow lighting. She stepped carefully onto an oriental rug that looked like it should be hanging on a wall.

"What do you think," MK asked as she handed Jenny a key card.

Jenny smiled. "Beats Motel 8."

"There was a slight mix up so I had them upgrade us. We'll only have one room but... it's the Mayfair Suite," MK said. "I'll sleep on a hide-a-bed but your room should be beautiful."

"I hope I can make it to the bed. Point the way," Jenny said.

Inside the luxurious six hundred square foot suite Jenny opened double doors into her bedroom. After two long strides she fell face first into the white down duvet. "Pajamas," she moaned.

"Our luggage isn't here yet," MK said. "Try this." MK dropped a plush white robe on the bed beside Jenny. Jenny looked. Jenny grinned.

"Good enough for me," Jenny said. "Can you get our luggage from Bruno when he drops it off?"

"Absolutely. Oh, and we don't need to be to the Broadway Banquet Room until 11:00. Sleep in. I'll take care of everything." MK flipped off the lights and closed the double doors behind her.

For a moment Jenny considered changing into the soft robe, but just for a moment, because that would require movement. Besides, happiness is a comfy bed after an exhausting day. It felt luxurious.